Advance Praise for *The Yellow Ribbon Snake*

"**The Yellow Ribbon Snake** is a touching, well-told tale, peopled with characters real and tormented. Jacko, the main character, through whose eyes we see most of the story, is poignantly obfuscated by both a wrenching childhood and a Vietnam war wound.... Dailey has managed to take us into his world yet maintain the arm's-length clarity needed to understand all that Jacko does not. The language is tight and simply eloquent, the characters which drive the story are multi-faceted and complete, the setting is vivid."

—Nancy E. Turner, author of *These Is My Words*

"In **The Yellow Ribbon Snake**, J.R. Dailey leads us through Jacko's unforgettable world behind the truckstop; his box of a home a big step above the 'lowlifes' down the draw; his friends in the cemetery; the tortures of the bad things in his mind; the goodness that keeps them at bay. It's a world you'll want to hold on to as much as he does."

—Pete Fromm, author of *Indian Creek Chronicles*

"J.R. Dailey gives us life on the fringes, rife with secrets and mystery. Homeless Jacko is a thinking man who sees Elvis driving an eastbound (where else?) Freightliner and loves a fried bologna and mustard sandwich. Ruined for human society by Mom and Vietnam, he sees and hears the dead and spends a little time in their land—and is distilled to the essence of humanity, innocent and wise. **The Yellow Ribbon Snake** contains the truest dialogue you'll hear west of the Mississippi. This is the most unsentimental but heart-scalding book I've read this year."

—Meg Files, author of *Home Is the Hunter*

The
Yellow Ribbon
Snake

a novel by

J.R. Dailey

JOHN DANIEL AND COMPANY, PUBLISHERS
SANTA BARBARA, CALIFORNIA, 2000

An excerpt of this novel first appeared in *Sandscript*, under the title "A Brave and Wondrous Thing."

Book design by Eric Larson
Cover illustration by Patricia Chidlaw

Published by John Daniel and Company
A division of Daniel and Daniel, Publishers, Inc.
Post Office Box 21922
Santa Barbara, CA 93121

LIBRARY OF CONGRESS CATALOGING-IN-PUBLICATION DATA
Dailey, J. R. (Janet R.), (date)
 The yellow ribbon snake : a novel / by J.R. Dailey.
 p. cm.
 ISBN 1-880284-37-5 (alk. paper)
 I. Title.
PS3554.A289Y45 2000
813'.54—dc21 99-22460
 CIP

For my family,
dead or alive

Acknowledgments

My gratitude forever to Harlan Ellison for the letter that kept me going.

Special thanks to Jeanette Deslauriers for telling me what I couldn't see; Meg Files for her endless encouragement; Pam Marlow for hanging out with me on the long drives to and from classes; Eddie Akers Truck Service; L.L.C. of Graham, Washington—keep on truckin'; Ronald E. Penning, Medical Legal Investigator, Supervisor of Forensic Science Center, Pima County Medical Examiner's office in Tucson, Arizona, for the interesting conversations about the stages of the dead; former instructors and fellow students of Pima Community College creative writing classes for their positive criticism; Chuck Felts for his delicious *bon mots;* Paul Larson for listening to me whine; Juan Moreno for sharing what a man really thinks; John and Susan Daniel for believing in me; and James P.F. "Pat" Egbert for his, well, attitude. Any errors, embarrassing or otherwise, are entirely my own.

THE YELLOW RIBBON SNAKE

I: Jacko

SOME PEOPLE SAY YOU CAN TALK to the dead all you want but they're not going to answer. Maybe the people who say that have never listened.

My name is Jacko and I'm a thinking man. I think a lot about my grandma and whatever happened to Mother and how much I'd like to have a dog.

The cemetery was quiet and peaceful. I sat on the ground and leaned back against the cold, rough wall. Looking at the faded plastic flowers on the flat markers sunk into the brown grass made me sad. I closed my eyes and the specks behind my red eyelids swam around and it was nice just to sit in the sun out of the cold wind and visit with the people below.

Palo verde trees had grown close to the wall and buckled it. Chunks of plaster had fallen off and showed the chicken wire and cement blocks underneath. Of course that makes me think about what Grandma and my friends look like lying so peaceful in their coffins, some longer than others, but all of their bodies just as dead.

I shifted a sharp rock out from under my behind and turned up my collar and thought about Mother. She left without saying goodbye over thirty years ago, and I wonder all the time about what happened to her. She's not buried here because I've

looked at every grave. Her name was Ellanor Lee. I've always
been meaning to do something about finding her but life sort of
seems to get in the way.

I hopped back on the wall and faced the other way. Right
across the road from the cemetery is the little frame house we
all lived in. Grandma took care of Mother, my sis, and me, Jac-
ko, who used to be John Boy. I had a little dog then, brown and
white, and his name was Corky. He got run over and we buried
him under the mesquite tree in the back yard. I cried so hard I
couldn't go to school for two days.

Now there's a chainlink fence around the whole block of
my old neighborhood. The cemetery has bought it all. Every
house, even my grandma's is boarded up tight as a tomb. Except
for old Mrs. Wilkers, that is. She's the only one left. I'd talk to
her when I'd see her out in the yard, but that hasn't been lately.
She doesn't make much sense anyways and I could never get
her to talk about Mother. When Mrs. Wilkers leaves, the ceme-
tery people are going to tear everything down and when they do
that, Grandma's house'll be gone and I won't be able to sit on
the wall and look at it anymore and wonder about Mother, then
what? But I guess dead people need a place to stay too.

I wonder if my grandma is a skeleton yet. Maybe Mother's
one too, or maybe she's still pretty. I crossed my arms against
the slicing wind and shivered in the weak sun and remembered
the last time I saw her.

She looked like a pale snow princess in her white silky
dress, her long golden hair fanned out on the pillow and her
gray ice eyes freezing into my head. "What color did you bring
me this time John?"

"I could only find yellow, but I got two."

"I told you didn't I? I need pink to finish my rug."

I knew what the punishment was going to be. And some-
times it wasn't so bad and sometimes it was. "Please, oh please,
they match your hair."

"Yes, I do have beautiful hair. Men like long blonde hair,
don't they John? But I wanted pink ribbons. Come here beside
me."

She sat up and ran her pale thin fingers through her hair, strands of it catching under pointed red nails, and took the withered funeral wreath from my cold hands. Dead petals scattered on the white sheets as she pulled at the yellow bow and it came apart like a ribbon snake and wrapped around my head, covering up my eyes, and over my wrist, tying them to the scrollwork on the iron headboard. My clothes slithered away and the yellow ribbon snake wrapped around my ankles and the cold sucked into me and I couldn't see and I couldn't move.

"Pink ribbons, John. Pink."

She'd hurt me if I made a sound. Her fire fingernails pinched and nibbled at my neck and scratched across my chest and—and down on further and everywhere she touched left a burning. And then she used her teeth. I was warm in her mouth when she bit me.

I screamed. I tried to hold my breath so the screaming would stay in my head but I couldn't. "Grandma, oh Grandma please."

Then Mother made a funny sound like a hard, sharp cough and I felt her leave me like she jumped off the bed backwards. She'd never done that before. I heard scuffling and bumping, then nothing.

I don't remember how long, it seemed forever, before Grandma undid the ribbon and wrapped me in a blanket. She held me on her lap and rocked me like she hadn't done since I was real little. "Oh John Boy, my baby. It's all right, it's all right now." My grandma is the only person who ever loved me more than anything in the whole wide world.

After that I never saw Mother again. Grandma didn't talk about her ever, except to say she went home to her people. I never talked about it again either. What good would it've done?

I try not to think about that bad time, the last time I saw Mother, because sometimes she was kind. I always knew when that was going to happen. She'd call me her Johnny, her Sweet Little King John. She'd smile and toss her hair over her shoulder and pat the bed. I'd crawl in and snuggle into her. Her hands would be like something separate from her body, scurrying over

me everywhere like soft little animals. And her lips would fol-
low her hands and she'd show me what to do and everything
was soft and warm and beautiful and I loved her. That is, when
she was nice. Mostly she wasn't, like the time with the trunk.

I sat on the wall and stared at Grandma's house and it was
like I had x-ray vision and could see through the plywood
boarded over the basement window. The trunk, made from
black wood and bound longways with strips of lighter colored
wood, the corner fittings and latches of polished brass, sat se-
cret and still at the foot of her bed.

She'd sit on a stool and open the heavy coffin-like lid and
take out things like an empty red valentine candy box and a
man's handkerchief and a little fuzzy white bear with "I love
you" on its collar. Mother'd look at them slow and long, then
take out more stuff—black and white photographs and letters in
yellowed envelopes and black phonograph records, thick and
scratched and brittle as glass. She slapped me with one once
and it broke and she slapped me again for breaking it.

Even when it was cold, she'd sit there on that little red,
three-legged stool in a thin nightgown or nothing at all and
stroke herself with the fuzzy white bear and cry. My father gave
her those things and then he got killed.

She never let me touch anything in the trunk but, oh, I
wanted to. And once after she got done being nice, she got out of
bed and opened the heavy lid and said, "Johnny, my Sweet Lit-
tle King John, come see what the fairies came and left for you
last night." And, oh man, was I happy. I jumped into my pants
and was beside her in one leap and she stood up, then scooted
the stool closer and sat me down and I started to look into the
trunk and she crashed down the lid and squeaked in a loud
witch voice, "And here comes a chopper to chop off your head."

I put my arms over my ears and held my hands above my
head and fell on the floor. I made myself real small, as small as
a mouse, didn't make any noise and tried not to breathe.

My sis heard the crash from outside and by the time she got
there Mother'd put her robe on. My sis said, "What did that
creep-blonde bitch-fuck do now?" She could talk like that

because it wasn't her Mother. So that time I was rescued but I've never gotten away from Mother and I wish I could.

If I sit real still on the cemetery wall and listen close, I can hear my grandma talk to me. Mostly it's words she said a long time ago and I know it's me remembering. I'd hug her strong legs and she'd squeeze my shoulder and pet my hair and say, "What is to become of you with that lost look of your father's?" She shouldn't have worried so much because here I am.

The white paint has blistered and peeled and flaked away from my grandma's house like the hair off a mangy old dog. The peaked roof is patched with different colored pieces of tarpaper. The square louvered vents on each face of the peak have screen wire nailed on them to keep the critters out. Me and my grandma'd climb the mesquite tree in the back yard and, with a rope, pull up her old purse packed with our sandwiches and her Bible and a bottle of tea and have a picnic under the roof. We'd sit on an old blanket and she'd read her Bible and I'd pretend we were on Mount Everest and I was Sir Edmund Percival Hillary.

Our mesquite tree and some of the other big trees in the neighborhood have been tagged so they wouldn't get dozed down like they usually do. The shade will be nice to sit in and have a picnic and visit with the ones below. Me and my grandma never had another picnic after Mother left.

Well, my grandma isn't too far from home and my sis, Marie, lives with her boyfriend, Timothy Francis Joseph Salazar—we call him just Salazar—on his five acres in the country. He's a cop and wants to marry her but she won't because she's fourteen years older than he is. She calls him a baby and that makes him mad. He's big and tall and has a sad face and she dyes her hair, so they look about the same age, and what difference does it make anyways, we're all going to die.

I don't remember my father, he died in Korea before I was born. My grandma called him her Little King John. He was married once before and my sis had a different Mother who died when Marie was a baby. Then he married Mother and after he died my grandma took care of all of us because he asked her to.

Now my sis tries to take care of me. She feels guilty for moving away and leaving me with Mother.

Grandpa worked for Southern Pacific Railroad until a train ran over his foot and cut it off. I always wondered what happened to the foot. Did they throw it away or give it back to him? I never saw it around the house. After that he kind of just sat around in the dark until he died.

The chicken sisters, Becky and Bernice, are buried between my grandma and the wall. They lived next to us and I'd pull my wagon and pick up anything good on the way to their place, like kindling, then sneak in their chicken coop and steal eggs to give to Corky. And, oh man, when my grandma found out, I had to work a long time for them for free.

They'd invite me into their trailer for coffee. It was the dirtiest place I'd ever seen. Chicken poop mashed across the floor, feathers stuck on the greasy ceiling, and plucked chickens in the sink. But the coffee, made with canned milk and lots of sugar, tasted so good I'd have two or three cups and forget about the smell.

Somebody hauled out their trailer and took the chickens after Becky got killed by a train when I was in Nam, maybe the same one that ran over grandpa's foot. Her old pickup stalled on the tracks. Instead of getting away she tried to unload a crate of chickens. Bernice always told her she was getting fat and slow. And that was right. Feathers everywhere. A little later Bernice died of a broken heart.

But I wanted to get back to Slammers before the ladies got to work. That's a bar across the truckstop on I-10 where the truckers hang out. I live behind the truckstop on the bank of a mostly dry wash. Me and my best friend, Sonny Ray, have our house fixed up pretty good now. The house I lived in before was made out of yucca sticks and black plastic sheeting, something like a teepee. That worked okay, but if it was too windy it would blow over or away.

So I threw in with Sonny Ray and we got us a big wooden machinery crate and covered it around with a tarp and made a door from a mudflap. The cardboard divider gives us each our

own space. But there isn't enough extra room for a dog and even in the Arizona desert it gets pretty cold in the winter and I wouldn't want my dog to get cold.

Anyways, I cut through the desert—it's only a mile or two north to the truckstop from the cemetery. I was hurrying because Friday's the best time, payday, so there's lots more ladies.

I got off the path a little and almost missed the white five gallon bucket laying in the brush. Clean buckets bring twenty-five cents apiece at the scrap place. I eased off the lid carefully so's not to crack it. Drywall mud smells sour if it's been closed up awhile, but it smelled more than sour and not from mud. I poured out the puppies, five little skeletons tangled together, floating in a jelly of dark brown fur, and covered them over with leaves and dirt and wished I could kill the person who would do something like that. Maybe Mother looks like those puppies now. My grandma doesn't, she's been dead too long. But I couldn't think about stuff like that. I tossed the bucket as far as I could and hurried towards Slammers.

II: Jacko

THE NAME SLAMMERS IS PAINTED IN big red letters on the bare cement block wall directly over the front door. A friend of mine did the lettering about a year or two ago. He also painted the front window black on the inside so you can't see through it. I remember David got paid seventy-five dollars. That was a lot of money. He never made anything off his paintings, except I gave him five dollars for one of a little black and white dog. It reminded me of Corky, even though Corky was brown and white. My sis keeps the painting for me. If ever I have a room I'll hang it up. David walked in front of a semi and killed himself. Parts of him got stuck in the driveshaft. What a mess. Poor David. Sonny Ray found a piece of his skull with curly red hair still on it about three weeks after. We wrapped it in Sonny Ray's best bandanna and buried it and said a prayer.

So I went around behind Slammers and laid a nickel on the back step and got settled in under the bushes. The prettiest ladies you ever saw work in the back rooms and they all wear really short skirts and lacy underwear. I use nickels now because hardly anybody will bend over to pick up a penny.

A black car drove up and let out two ladies. They started for the door and my heart pounded so hard I was afraid they could

hear it. They got almost to the step when, oh man, I saw my sis cruising the parking lot. She's been wanting me to go to a place where they can help me. Now, I'm a thinking man. I've thought and thought about what she said and I still can't figure it out. Help me with what? Besides, I don't want to live inside. I feel smothered breathing those tiny pieces of dust floating around in the sunshine and there's scary things that tangle and twist and coil and are hard to get away from.

I told her all that stuff but she never quits asking. And sometimes she makes me come with her and take a bath and get new clothes. I don't mind the bath, but her soap smells like perfume. One time I let the shower run and didn't get in. I wet my hair and put on the new clothes. It didn't fool her none. She picked up the soap and said, "Why didn't you use this Johnny?" I told her my friends would smell me and call me names so she let me use the dish soap. That same time after we ate, she said why don't I watch TV awhile and she would do the dishes. So I watched TV awhile, then I ran away. But she still goes up and down the freeway and asks everybody how I am. I'm a man and can take care of myself.

I was so busy watching my sis I didn't get to see who picked up the nickel. A whole nickel wasted. Now I sure was going to have to think of something before my sis found me. She doesn't waste time tromping around. She knows where I hang out and goes there and waits. I figured I'd have to hide out for a day or two some place she doesn't know about.

Sure as anything, if I went home she'd be there poking through my stuff. She'd flap her hands and say, "My God Johnny, how can you live in a box?" I can't make her understand that a house is just a bigger box.

So I lay on the cold ground and made pictures in my head of I-10 westbound. There isn't much going the other way. Westbound's the easiest way to walk picking up cans because Phil's scrap yard's that way and he lives there all the time so he can watch his stuff. I only go there every month or so. My sis would never think to look in a junkyard.

Phil always needs somebody to help take things apart. The

last time I was there he had a pile of aluminum chair frames. He let me use the magnet to see which screws were steel. After I took them out he weighed me just for fun on his flat scale. One hundred twenty-six pounds. He said if I was an aluminum can I'd be worth $42.84. But he wouldn't sell me until the price of aluminum went up. That was a good joke. For lunch Phil fixed my favorite sandwich, fried bologna and mustard on white bread. What I had to figure out now was how to get to Phil's without my sis seeing me.

I thought about all that stuff while I shivered under the oleanders that grow between the back door and the dumpster. Everything on the bushes is poisonous, the flowers most of all. They don't smell good, but they sure are pretty. Sometimes I pick up trash in the parking lot at Slammers, and Louella, the bartender, told me don't chew on those leaves or I'd be as dead as Elvis. She thinks Elvis is really dead but I don't, because there's times I hear him singing a long ways away. And once I saw him driving a Freightliner eastbound with a load of steel. I guess I won't get poisoned just by lying in the dry leaves because I'd be dead by now since I've been doing it for so long.

I must've dozed off because it was dark when I heard Louella laugh. She stood under the light by the back door smoking a cigarette. The light shone down on her face casting bright bumps and dark hollows and with her tangled, curly hair made her look old and ugly but she sure isn't. She was joking Salazar around. He's okay for a cop. I think maybe he saved my life this past summer when it rained so hard.

It happened when I was trying to get home to feed Norton. Norton had two legs left and they were both on the same side, so he could only go in circles. I kept him in a paper cup and fed him a fly every day.

For most of the year the wash I live by is dry sand. Except, when the summer rains come it runs hard and fast. It was only running a little when I started across. Towards the middle it got deeper. The sand kind of oozed away from under my feet and I lost my balance. There was a big mesquite tree growing on a little island. As I sort of tumbled by I grabbed onto a branch and

hollered like crazy. Well, the water was roaring so loud nobody was going to hear. I said goodbye to my sis and all my friends and asked Jesus to tell Norton I was sorry I didn't feed him his fly. The water splashed in my face and I tried to climb higher, when somebody yanked me backwards out of the tree. It was Salazar. Later he said he saw me heading for the crossing, but didn't think I was dumb enough to try and wade across, then thought probably I was, so he came after me.

He's a lot bigger than me and the water didn't come much over his knees. He said, "Jacko, you dumb shit, I'm getting wet." Well, he carried me out to the side I wanted to be on and asked was I crazy. When I told him about Norton he said, "You mean I got wet because of a fucking spider?" He said a bunch more cuss words, then waded back to his car. One day Norton wasn't in his cup. I looked all over but I never did find him.

So I listened to Louella and Salazar joking and didn't move a muscle. That was easy, being so cold and stiff. If Salazar saw me, that was the end. He watches me like my sis does. He told me she was beautiful. I don't know why he said that. She isn't as pretty as the ladies that work at Slammers. Her hair is gray under the dye and she's fatter than she used to be.

I lay still on the cold ground and made myself invisible and thought about Phil at the junkyard. He reminds me of a brown plastic bag full of trash. He's kind of lumpy and all the same color. You can't hardly see his house, there's so much stuff piled around. His living room is the office. Everything in there is kind of the same color too, except for the yellow vinyl couch with a crack all the way across the seat. Once, I tried to look at the magazines stacked on an ironing board, but they'd been wet and were all stuck together.

I couldn't walk to Phil's because my sis might be cruising the freeway, so I thought maybe I'd sneak a ride on a big rig. I could go across to the truckstop parking lot and crawl up on one of the spare tires hanging underneath the trailer. Or maybe I could hang onto the bottom of the truck like I saw that guy do in a movie. And, oh man, I saw myself wearing real boots with laces and the wind blowing back my hair, and, and...how

would I get off when the truck got to Phil's?

I was thinking about that part when Louella tossed her cigarette and went inside. Then Salazar said hmmm and bent over and picked up something. He flipped it with his thumb and caught it out of the air. My nickel. He jiggled it in his hand and looked around. And then he looked straight at me. How could he see in the dark? He must've heard my heart pounding.

Salazar coughed and said, "Up to your old tricks again. C'mon out Jacko, I need to talk to you." Everybody does what Salazar says, except, of course, my sis.

So I came out and waved my arms and stomped my feet and sat on the step. He gave back my nickel and stood over me and it was like looking up the side of a boxcar. He said how much my sis worries about me. Then he sat down on the step too and stared at me real long, then smiled. Salazar smiles maybe once a year, so I knew he was going to say something important. He squeezed an up-and-down line in his forehead and his thick eyebrows came together and it was like a black butterfly landed on his nose and spread its wings. "Marie knows about a place. So do I and I can't say I'm as enthusiastic as she is, but she thinks because conventional therapy hasn't made any difference in your attitude, maybe a stay in a small, private facility will."

"But I'm a man and can take care of myself."

"I know. I know you can and I think you live like you do because at this point in your life you need to. But check it out Jacko, then maybe Marie will leave you alone."

Well of course, when Salazar says something is important, it is.

The next morning him and my sis picked me up at the truckstop. He looked funny in regular clothes. My sis doesn't like to come to my place alone because she has to walk from the truckstop and's afraid there's something hiding in the bushes. I told her don't be scared, it's just my friends.

The first thing she said was, "Johnny, we're going home to get you a bath and clean clothes." We went to Salazar's house and that's what we did. I like it there. He has trees.

When we got to that place Salazar waited by the car while me and my sis went in. It felt like a hospital but smelled like the bathroom at the truckstop. I got nervous because there weren't any windows. I peeped into the lounge and the people all wore pajamas except the people in white who stood with folded arms and watched the people in pajamas.

The pajama people walked up and down or sat against the wall and hugged their knees. The TV was on but I don't know if anybody knew it was, even the people watching it. I said hi to an old lady who drifted out in a wheelchair, pulling it along with one foot. She had food on her clothes. She glanced around like she wondered if it's okay to talk and reached under the blanket on her lap and pulled out a doll that didn't have any eyes. She said her baby was dead but I could hold it if I wanted to. My sis wouldn't let me.

We went into a little room and waited. I didn't want to be there because it didn't have any windows either, but my sis smiled and I sat down. The picture on the wall of a guy with a beard and slicked back hair reminded me of someone. On the desk, besides the usual office stuff, sat a box of raisins and a flyswatter.

A lady came in from the door behind the desk and my sis gave me a hug and said she'd wait outside with Salazar because it might be easier for me to talk without her around. And that's right. My sis is always saying what she thinks I think. How could she know?

The lady had big hands and feet and looked like those naked trolls they sell for good luck at the truckstop store. Only she had on a shiny gray dress with little pink flowers and her legs rasped together. When she sat down, the chair squeaked as she reached for the raisins. "You may call me Mrs. Bagshaw, and what are we here for?"

Well I knew why I was here, but I didn't know why she was, so I didn't say anything. Then she smiled a yellow smile with lipstick on her teeth. "Not saying anything are we?"

I wished she'd talk right. My grandma made us talk right, and read and think. A long time ago, before she married grandpa,

she taught English. Mrs. Bagshaw flipped through her papers. "I see your sister has taken care of the paperwork. Excellent. Perhaps you could tell me a little bit about yourself?"

"I don't belong here. There's no windows and no trees."

"Well, we do have air conditioning and heating, and since this is a new facility, the trees in the back aren't very large. Did you notice the nice hedge in front? Now really, Mr. Lee, you must tell me about yourself."

I made up some stuff as I went along just to keep her happy and finally I said I just wanted to satisfy my sis, to try and make up for the times I didn't pay her much attention.

And, oh man, Mrs. Bagshaw looked at me like I'd given her a fresh doughnut. A handful of raisins went in her mouth and she picked up the flyswatter. She tapped herself on the side of her head with it while she asked through a mouthful of raisins, "And what else do you do to satisfy your sister?"

"I never satisfy my sis. That's why I'm here."

She nodded for a long time. Then she said, "Mr. Lee, has anyone ever discussed this situation with you before?"

"What situation?" I asked.

"Have you ever had any counseling," she said "about insects?"

"I had a spider named Norton," I told her.

Her eyes squinched shut and I thought with all the black stuff on her eyelashes it'd be hard to get them undone. But she popped them open so wide the white showed all around the blue. Then she jumped up and her dress was stuck to the back of her legs and barely covered her behind. The trolls at the truckstop store don't wear underpants and I wondered if she did. Thinking about that made me want to laugh.

She took three long steps to the wall, then wheeled around and said, "And do you know who the president is?"

The only president I could think of was President Johnson. He made me go to Nam where I got hurt in the head and almost died, except I can't remember why. My sis knows because she gets my check. She told me once but I made myself forget because I don't like bad stuff in my head. Thinking about that

made me afraid like my sis is afraid to walk through the bushes to come and see me. The president's name is like that: Bush. But as soon as I thought it, I knew it wasn't right. There's a new president now—I don't keep up on politics too much. It was just on the tip of my brain when Mrs. Bagshaw said, "How did a cockroach get in here?" And she bent over and hit a raisin on the floor with her flyswatter."Johnson," I said, "The president is Johnson."

She looked at me like I'd said something crazy and then the phone rang. "Yes, Doctor, Irma here." Her face went soft around lipsticky lips and she said to Doctor, "Yes, yes, yes," and told me to wait in the hall.

I found my sis and Salazar out in the lobby and the old lady still hovered in her wheelchair. I said hi again and she handed me her doll. It really did have eyes but they were stuck shut with oatmeal or something. I took the doll to a water fountain on the wall and washed its eyes and they opened. I handed it back and the old lady looked at its eyes, then threw it against the wall and its head fell off and rolled under her wheelchair. She said, "That's what you get, that's what happens to bad boys."

I picked up the doll and put its head back on. The food on the old lady's clothes was still kind of wet so I used some to stick the doll's eyes shut again. She looked at its face and squished its cheeks hard with her thumb and finger and put it back under the blanket on her lap.

So I thought, if this place was to help people, how are they helping this old lady? She made me think of a little old dog I found a long time ago by the freeway. It must've got out of somebody's car and got lost. That's the way I made myself think about it anyways. I get sick if I imagine people being cruel to critters. So I took it to my place and tried to make it happy, but the dog just lay on a piece of carpet for three days until it died. Sometimes it's better to die.

Mrs. Bagshaw poked her head out of the door and said Doctor is ready. I went back through her room and into the next.

Doctor had a beard and looked like the picture in Mrs.

Bagshaw's room. Maybe they're brothers. He sat there with one leg cocked and his foot on his knee snapping a red rubber band lightly on his wrist every few seconds. He picked a squashed raisin off his knee and rolled it into a little ball and threw it into the trash can. He quit snapping his rubber band, sniffed loud and said, "And what can we do for you?"

Maybe it's a rule in this place that people in charge all have to talk the same. While I tried to figure out what he could do for me, I asked who the guy in the picture in Mrs. Bagshaw's room was. He straightened his coat and tie and said, "Our father, Freud." I knew they were related.

I handed him the papers Mrs. Bagshaw filled out and he read them and said, "Hmmmm." Then he pulled the rubber band and snapped his wrist hard and sucked air in between his teeth.

"Well, Johnny."

"Only my sis calls me that. I'm Jacko now."

"Yes well...Jacko, what seems to be the problem?"

"I don't have a problem, but I guess my sis does with me."

Doctor sat there with his elbows on the desk, his fingers spread and fingertips touching and looked at me with pebble eyes and a smile that didn't make it to the rest of his face. "Yesss. I see. So then, tell me, what one thing would you like, anything now, hmmm?"

I didn't have to think about that question. "I'd like to know what happened to Mother and I'd like my very own dog. That's the only two things I want."

Doctor tapped his fingertips together a few times and said, "Hmmm...your Mother, yes, and a dog, hmmm?"

Then he sat there forever and didn't say anything, just kept lightly snapping the red rubber band. So I asked him why he snapped himself. He said it's an idea that what people think can be changed by something painful happening when they think of stuff they don't need to be thinking. But he didn't know how to test this idea on anyone until he could figure out what they thought or something like that.

He looked some more at his papers then slid his gaze up the

wall till it stuck on the ceiling. I suppose he forgot about me. For awhile I sat there thinking about the pajama people. Why don't they just leave? Maybe they're afraid to walk through the bushes like my sis. When I have bad stuff in my head I talk to Sonny Ray. He says something nice to try and make the bad stuff go away. Why didn't Mrs. Bagshaw and Doctor say anything nice?

Jeez, I thought, maybe Mrs. Bagshaw and Doctor don't know how to say anything nice. Maybe they make everybody here wear a red rubber band and eat raisins.

I told Doctor it was nice talking to him, but I had other things to do. He shook his finger at me like I was a bad boy and pushed a button on his desk. One of the pajama people watchers came in, a big black guy and grinning, but his eyes were as flat as the raisin on Mrs. Bagshaw's floor. He stood behind me and put a hand softly on my shoulder and I got so scared I couldn't move.

Doctor took off the rubber band and fiddled around stretching it between his thumb and finger on one hand. Then the rubber band got away from him and I saw it coming and closed my eyes. It hit me on the forehead.

The next thing I knew, I was lying on the floor. My sis and Salazar and Doctor were all crouched around me. They all stood up at the same time and Salazar grabbed Doctor by his tie and gave him a little shake. Salazar gave him his snake look that can freeze a rat to its tracks. Everybody calmed down and my sis helped me up and I told her I was okay and about the rubber band and the raisins and everything. Salazar gave Doctor's tie another little shake and let him go. He kept saying, "How unfortunate, how very unfortunate." The black guy shook his head and put his hands behind his back and stepped against the wall.

Doctor fixed his tie and shrugged his coat on straight and smoothed his hair back with both hands. He sat down behind his desk and didn't know what to do with his hands since he'd lost his rubber band. So he bit his thumbnail and gazed at the ceiling and said through a Sunday school smile, "It's very

unfortunate, yes is it not, there is absolutely nothing we can do for your brother."

My sis started to cry—one of these days I'm going to make her laugh—and said, "It's my fault, I abandoned you to your fate." She talks like that, about how she "neglected to consider me" when she left me alone with Mother and my grandma so long ago. You'd think by now she'd have it figured out that I'm okay.

She would've went on longer but Salazar touched her hair and she got quiet. Then he squinted one eye and made his hand like a pistol and pointed his finger at Doctor. Doctor put both hands out palms up and raised his eyebrows and then we left. On the way out, I told the old lady she should think about going to help Jesus take care of her baby. She smiled and nodded and patted the blanket.

In the car, Salazar told me he felt the same when he saw me walk into that place as he did when he saw me head for the crossing when I tried to wade across the wash, that something bad was going to happen, that he was going to have to come after me again. Him and my sis were hanging around in the hall when they heard me yell for a medic. I don't remember that, but I'm glad Salazar saved me again.

They dropped me off at the truckstop. I saw Sonny Ray digging in the dumpster behind the cafe. I said come on out and listen to something good. We laughed about Mrs. Bagshaw's underpants. "You know, I'm glad I went. Maybe now my sis is happy to know there's nothing wrong with me. Find anything good?"

He dumped the garbage out of a few bags and crumpled them into his pockets. "Naw, this ain't a good dumpster for finding stuff and I'm skint. Tomorrow I'm walking the freeway for cans, you comin'?"

I needed a good long walk to get that place out of my head. "Sure."

III: Marie

MY BROTHER DRIVES ME NUTS. THAT whole experience sucked. I should've known better. Sometimes I wonder who I'm trying to save.

We drop off Johnny at the truckstop and on the way home, Salazar won't lower himself to say I told you so. But I can feel the words leak out. They're maybe pale yellow or faded orange. They float around the inside of the cab of his pickup until they seep out through the crack in the side wing. "Now what am I going to do?"

"Leave him alone," Salazar says, that and a bunch of other stuff.

"Sorry. Run that by me again, I wasn't plugged in."

He sighs. "Marie, why do you talk like that?"

"Like what?" But I know what he means. He hates my slang. He says he hears that cute street shit all the time and he would rather not hear it at home. I don't work, he doesn't want me to. I make it easy for him to work. I do everything around the house and that's okay. He takes good care of Johnny and me.

I try not to talk slang because it seems adolescent. It pops out and most of the time I don't give a shit, there's hairier things to worry about than that.

We get home and Salazar stands in the back yard looking

around and I know he's thinking about where the corrals and hay shed are going to go. He wants a horse, a couple, because they're herd animals and pine away from loneliness by themselves. He used to rope. Now that he's older, he thinks about how the calf feels. I tell him he hangs around with Johnny too much.

I'm in the kitchen. I watch him out the window until he gets done thinking. He wipes his feet, then, one at a time, looks at the bottom of his boots before he comes in. It took a long time to train him to do that. He doesn't mind, he likes me to be domestic.

I throw my arms around his waist and bury my face on his chest. The small silver crucifix and Mary medal he always wears under his shirt pokes me in the temple. He is a rock and I'm the little bird who shits on him. I say, "I do love you, I do."

He holds my chin in his palm and says, "Sometimes I think you're a taco short of a combo plate, but I love you too."

"Look who's talking cute."

He is aroused. One of the most amazing things in life is, how a man has room for a hardon in tight jeans. Save it for later? I think not. I go to the bathroom, get undressed and put on my robe. I can't be naked in front of him. I've never been naked in front of anybody except Grandma and the doctor, and the doctor only on the parts he needed to see. I know I smell, bath time is in the evening before bed, but Salazar's not going to be burying his face between my legs.

I like it when he needs me now, I feel pretty. I almost believe it doesn't matter to him that I'm older, fatter and grayer than he is. Well, older and fatter. I'll never be grayer.

I go into the bedroom and he's under the blankets. He knows I don't like to see him naked. I get in bed and take off my robe under the covers. He thinks that's sexy. He's on his back and I wrap my leg around his and press myself against him. I say, "You're going to have a stinky leg."

I touch his face and feel his smile. I kiss his flat stomach and I know he wants more, but I can't do that unless he's been in the shower first. So instead of kissing down, I kiss up to his

face. But to do that, I'm on top of him and he's in me and we roll over. It doesn't take long because he needs me now and I feel pretty.

Then he talks to me, really talks to me like he always does after. He says, "The only thing about a horse is they can't sleep with you. Remember Fido?" I don't answer because I like to be warm and still and listen. He keeps on talking about how much he misses Fido and he'd like to try roping again. "Rosario and me were a good team. I headed, he heeled. We never missed—well, not very often." He won't get another dog, he says, until he either has to save one's life or goes to the pound and finds one he falls in love with, but maybe it's too soon after Fido. He talks a little bit more about dogs and horses, then just as he's dozing off he says, "Marry me."

He's asked so many times before, but I'm afraid he'll be sorry afterward and feel trapped, especially having to deal with Johnny, although that's what he's doing now. I kiss his hand and pet the curve of his neck onto his shoulder and he falls asleep. I can't let him sleep. We haven't eaten and we both need showers. He'd get up at two o'clock in the morning and crash around the kitchen and never get back to bed.

I shake him and he pulls me in tight. "Want some more babe? Okay, I'll stay just this once, but I don't know what I'll tell Marie."

I slap him on the arm. "Shithead."

"Oh yeah, and I was going to take you to Taco Bell."

"I didn't know we were going out."

"Didn't know if I'd feel like it. Now I'm full of energy. Let's go look at a horse."

He forgets he's naked and leaps up and stands on the bed striking a pose like Popeye. I laugh and cover my head with the bedspread.

"Look Marie, it's only my snake snapping around. It won't get you—at least not for an hour or so."

He's made himself hyper. We have to go out now. He makes a phone call.

In the pickup he tells me we're going to look at a horse this

woman has. Her boyfriend drove his truck into a ditch and went through the windshield. Now he's dead, she needs money and has to sell his horse.

We get there and she's waiting on the front porch of her trailer wringing her hands. In the old days people only wrung their hands if they were thin and pale and wan. Now, nobody in America is thin and pale and wan. She is dumpy and droopy with bulgy red eyes and a snotty nose. I feel so sorry for her.

"Hi, I'm Carolyn. The horse is out back."

She comes down the three steps and shakes our hands. The horse, a sorrel gelding, no white except for a star, is in one side of a double, good-size pipe corral with a long ramada for shade. There's scraps of hay around his feed bin, but he stands and looks over the gate at us, a good sign. He's not hungry and he's interested in the world. I like Carolyn for taking good care of him.

Salazar climbs through the fence and runs his hands all over the horse and it makes me think of what we did before we got here. Then he looks in his eyes and at his teeth and picks up each one of his feet. A horse touchy about his feet is too hard to shoe, and some farriers don't like to mess with them unless they tranq them first.

While Salazar does that, I chitchat to Carolyn about how neat and clean the place looks. Tears leak out. "Buddy did all this. He loved his horses. That's why it's got to go to a good home. He roped off him almost every weekend. Oh God, oh God, I'm sorry, excuse me."

She goes inside and I walk to the corral and tell Salazar, "Boy, she's really hurting."

"Don't know why. Buddy was good to his horses but not to her. He got drunk at a roping and, on the way to another bar, drove his pickup into a ditch and killed himself and his horse— the son-of-a-bitch. See the empty corral, the horse he killed was damn good."

Carolyn shuffles around the corner of the trailer, hands jammed deep in the pockets of an embroidered denim jacket like biker chicks wear. "Do you want to take him out?"

Salazar runs his fingers through the gelding's forelock. "Not now. About a year ago, I went to a practice roping to watch and I rode him then. Buddy asked me to cool him down."

"Buddy won a couple of buckles with him and money too. His name is Snort."

"Buddy won a buckle with his other horse too didn't he?" Salazar didn't wait for an answer, he just wanted to twist the knife. "I'll give you a call."

She knuckled her eyes and nodded.

In the truck, indignant, I ask Salazar, "How come you didn't tell me the whole story before?"

"Because I didn't."

"Don't you feel sorry for her?"

"No. Why?"

"Well couldn't you see why?"

"You mean because she's fat and ugly and broke? Because she chose to live with an alcoholic? In a month or so she'll find another drunk. I feel sorrier for the dead horse. I sure do like Snort though."

Oh well, to hell with finer feelings. I say, "You promised me Taco Bell."

IV: Jacko

NEXT MORNING ME AND SONNY RAY took off beside the westbound lane of I-10, the bright early sun on our backs. We filled a bag with cans and left it on the embankment to pick up on the way back. We'd gone a little further than usual because people don't drink as much when it's cold so they don't throw out as many cans. I was kicking through some tall, dry weeds and just fixing to say let's turn back when I saw a dead guy sitting under a mesquite tree.

Sonny Ray poked along a little behind me shaking dirt out of a can. Phil at the scrap place won't take cans with dirt in them because they weigh more. He gripes at me if there's even a grain of sand. He says nobody will pay good money for dirt. Sonny Ray came up beside me and saw the dead guy too. He dropped the can and said in a loud kind of whisper, "Jacko there's a man sitting under that tree—and he ain't been alive for a long time."

The dead guy smelled like candle wax and Grandma's basement where Mother lived, kind of dusty and musty. Good thing it was a guy too, guys go out and die all the time. It would be too sad for a lady to be so dead and alone.

Anyways, Sonny Ray stood there gawping at the dead guy like he'd never seen one before. "Shit Jacko," he said, "I ain't

never seen a guy that dead."

I shook my head because I couldn't talk. I remembered a truck wreck that happened a long time ago. A bullhauler with a load of cows went off the highway and rolled over. A lot of cows died. Some were hurt so bad they had to be killed. The driver didn't make it either. Everybody said he snorted crank and never slept. He had it coming for not taking care of those cows.

The highway people got some cowboys to round up the live cows and a truck came and got the dead ones, except they forgot one that landed in a little gully. Things dry out pretty quick in the desert and after awhile it didn't even smell bad. The bare bones sticking through the faded patches of hair on the brown and crispy hide didn't make me as sad as when the fur still shone and the cow had dark eyes looking at nothing. This dead guy was like that cow. Not real sad, but kind of sad, because he used to walk around like me and now he doesn't.

One of his eyes had shrunk and dried smaller than the eye hole but hadn't fallen out like the other one. Some of his scalp hung away from the skull and looked like strips of beef jerky growing hair. The dry leaves on his lap, his pants, and him were all part of the ground.

Sonny Ray lifted his ball cap and rubbed his head. He does this to think better. I've told him and told him that's why he doesn't have much hair. Then he said, "I wonder why nobody ever found him?"

And you know, that's right. So I thought for a minute and figured it was because nobody ever walks alongside the freeway in the weeds and bushes. Also, we'd gone further along even than the chain gang goes when they're out picking up trash. They sure cut into our aluminum can business. Besides, all I could see looking up the embankment were the tops of the truck trailers as they passed. Nobody could see down where we were.

"Something else too, old buddy," Sonny Ray said, "how did he die?"

And, oh man, I thought about that and remembered snipers

in the trees, except, I didn't see any trees tall enough for a sniper but I got scared anyway. "What if somebody killed him" I said. "What if whoever killed him is still hanging around?" I dropped my bag and tried to run away but Sonny Ray grabbed at me and ripped the sleeve of my jacket. He held his arm straight and pointed all around us. "Be calm old buddy, wouldn't be anybody hangin' around here after all this time."

Of course he was right. The dead guy had done swelled, popped and shriveled up and that takes a little while. But he didn't sit slumped over. Nope, he sat nice and straight, like I used to have to do when Teacher would say, don't sit hunched over or your spine will curve someday.

Well, his spine had done all the curving it would ever do. When I calmed down and looked close I saw the wire that tied his neck to the tree. I pointed to it and said, "I don't think he could've done that to himself."

Sonny Ray had his ballcap off and on a hundred times and when he started talking as fast as a Mexican deejay I quit paying attention. I remembered something. A sound. Caclack, caclack. The dead guy's feet had fallen off inside his boots because they were separate from his legs and on their sides with the toes together and I could see socks. The steel horseshoe taps on the heels of his boots were rusty but I could still hear caclack, caclack.

"Pits," I said. "Those boots are Pits's. So it must be Pits in 'em. He'd walk for miles on the pavement just to hear his boots make noise."

"I remember that."

"I told him and told him he was going to get run over and he'd say, naw he'd been walking on the pavement for a long time and he hadn't been run over yet."

"Yeah, he got that right, he sure ain't been run over."

"And you know Sonny Ray, wonder why the critters didn't eat more of him, only one arm's gone?"

"Got too many clothes on I reckon, and his head's tight to that tree."

Now Pits hung around with a lowlife named Monk. Nobody

else would talk to Monk because he's crazy and only talks to himself. I once asked Pits why he let Monk hang around and he said he felt sorry for him because he didn't have anybody.

The last time I saw Monk was in the dumpster behind Slammers. He was pouring the drops left in every bottle into another. Beer, wine, whiskey all mixed together. When he filled his bottle he'd take it back to his place across the freeway and get snot flying drunk. Monk lived a little ways up the wash from me and Sonny Ray with the rest of the lowlifes.

Sonny Ray talked fast and nervous like people do when there isn't anything else they can do. "Poor old Pits, I hadn't seen him around lately but I thought it was because he owed me two bucks, smells better now than he did when he was alive—looks better too."

It was a good joke but we didn't laugh very much. Pits was so small and puny. He used to remind me of one of Santa's helpers, with his red backpack that had all those neat zipper pockets. A cup and frying pan wired together, extra clothes, and anything good that he found he tied to the frame with dark blue cords that had little plastic squeeze things on the ends. When you squeeze them you can pull the cord. As soon as you let go you can't. They work lots better than tying and untying knots. How do they think of things like that?

Pits's most special thing was the Medal of Honor his father or grandfather won in a long ago war for doing a brave and wondrous thing. For killing a lot of the enemy before they killed him. I can still hear what Pits said. "He died for his brothers in arms Jacko, he really did. I wished when I was in the war I could've done that and won a medal." Then he nodded and ran his fingers across his white eyebrows, "It means you're the bravest man in the world."

Pits unfolded the bit of rag covering the medal as gently as if it covered something alive. The star was made out of bronze. Inside the star was a circle with little stars around the border. And inside the border a lady with a shield and sword fought a man. And all of that was held by an eagle. And it had a flat ribbon with red and white stripes and I wanted to touch it more

than I've ever wanted to touch anything.

Because the President of the United States had held it in his hands. The most powerful hands in the world. Hands that can sign a paper to let people live or make them die. A president sent me to Vietnam and I still haven't figured out if I lived or died.

Maybe Pits knew how my thinking went because he looked in my eyes and smiled. "Here Jacko, you can hold it." And I did. The Medal of Honor warmed my hand and I closed my fingers and pressed it heavy on my heart and I felt like someday I wouldn't be afraid anymore.

But of course the medal was gone with all the rest of Pits's stuff—we looked but didn't find anything. So we gathered up the cans and Sonny Ray said, "Don't talk about Pits to nobody. They might think we did it. Any way you want to look at it, it'd be a major hassle."

"Pits was my friend. I wouldn't hurt him any more than I'd hurt a fly."

And Sonny Ray said real serious, "Jacko, everybody knows you could never hurt a fly. It's people they're not so sure about."

I don't like to think about things like that, so I didn't. But what he said crowded out everything else in my head and I forgot to talk to him about Monk.

Usually winter in the desert isn't bad but sometimes it does get really cold. That's the way it got on the way back to the scrap place. The wind stabbed me through every coat I had on and the sky that's mostly so blue and clear got gray and heavy and it started to snow. Sonny Ray got his money and went off to spend it somewheres and I did like the bears do and kind of hibernated in my house. I lay there and listened to the truckstop noises and when the air brakes hissed, I pretended that was my pet dragon patrolling the perimeter of my space keeping me safe from the world.

Being so wet and cold, I didn't feel like going out at all. The cold doesn't bother Sonny Ray as much and he went out for food. So I had a lot of time to think about Pits. When it got a little warmer, I checked on my old neighbor. Sometimes when I

have extra I take him something to eat. Underneath his canvas he was all curled up in his blanket looking warm and cozy as a puppy in a basket. But when I pulled the blanket away it was wet and the cold had got to him and made him harder and colder than a truck load of frozen dinners. When we had time, me and Sonny Ray wrapped him in a piece of carpet and put him under the overpass for the highway people to take away.

Such a pitiful dying, but my grandma used to say the Lord works in mysterious ways and maybe Jesus felt sorry for him and took him home. I thought about Pits. He's dead too. But it seemed to me he might still be lonely, sitting there all by himself in the cold. So after the sun came out and it warmed up a little, I went back to see him.

Pits still sat up nice and straight, except his head hung a little more sideways and I had to tilt mine to tell him how sorry I was. I pulled an old tire out of the weeds to sit on and got comfortable and leaned against the tree with Pits wired to the other side.

I imagined myself as Pits sitting around with somebody showing the medal and dozing off against the tree. Then the wire around his neck. Not choking, but slowly, tightly, cutting his throat.

The wire must've hurt Pits and that's bad. He only wanted to be left alone to hear his boots make noise on the pavement and to tell about a brave deed done in a forgotten battle. I would've hung around a little longer feeling sad, except I hadn't brought anything to eat and the wind cut into me making me as cold as Pits's corpse. Pits was somewhere now nice and snug and I hoped he wasn't worrying about his medal.

There's always work to be had at the truckstop parking lot, polishing fuel tanks and rims, cleaning out sleepers and stuff like that. But that sort of work takes a while to set up and I was too hungry. So I said so long to Pits and headed for Slammers.

Louella, the bartender, won't let me in at the front because my sis told her not to. Marie wants me to live with her so she can keep an eye on me and Salazar can keep an eye on both of us. Only Jesus keeps an eye on Salazar.

My sis knows everybody up and down the freeway. One time at the truckstop store, I tried to buy one of those magazines they keep behind the counter. The guy wouldn't sell it to me. He said my sis wouldn't like me spending my money like that. So I had Sonny Ray buy it.

Anyways, Louella let me clean up the trash in the parking lot. It's about five acres of dirt, rutted and dusty but plenty of space to park and turn an eighteen wheeler. When I got done she called over to the truckstop and told them to give me something to eat.

I went around back to throw away a sack of cigarette butts, potato chip bags, and other trash drivers throw out of their sleepers when they're expecting company, and heard somebody talking. It was Monk.

He'd propped a wooden pallet up against the dumpster and was climbing through the slid open door on the side. His legs were wobbling so bad, I wondered if he'd fall off or get in when I saw his pants were wrapped around his ankles and tied with dark blue cord. Those little plastic squeeze things dangled on the ends.

The sack of trash worried me. I couldn't throw it away here because Monk yells if you get too close. So I took it with me to the cafe and threw it away in their dumpster. That dumpster is always full. Truckers throw away a lot of good stuff. The floor of mine and Sonny Ray's house is made with thick rubber mud flaps. When they tear away from one of the bolts, the guys who own their own trucks cut the top off the flap and make new holes. The company drivers just toss 'em.

By the time I got done eating it had gotten dark. Except down by the wash it never really gets dark. The glow from the truckstop makes enough light to see by. But you know, all the way home I kept thinking about those dark blue cords wrapped around Monk's pant legs. Where would he get cords like that? The only ones I ever saw were on Pits's red backpack. Thinking of that backpack with all those neat zipper pockets was like having Pits in my head telling me about the medal. And I remembered it heavy against my chest and how much it meant to

him and him still sitting there wired to a tree all dead and dried out and alone.

Sonny Ray said don't touch him, just leave him, he's been murdered. It's not like he died natural like my old neighbor. We'd get busted hard if anybody seen us messing with a murdered man.

So I lay in my house and talked to my grandma. Not out loud of course, people think you're crazy when you do that. I told her Monk killed Pits for the Medal of Honor. Most of the time she doesn't talk back but this time her calloused fingers brushed my cheek and her soft gray voice floated through my head and she said an eye for an eye John Boy.

V: Marie

I SIT ON THE DIRT SEAT BECAUSE WE'RE late to the horse sale and it's the only one left. The lowest bench on the bleachers puts your face almost at ground level of the small sale ring they run the horses through. Salazar doesn't sit with me. He won't have dirt kicked in his face, even by a horse.

He's standing up in the balcony above the sales office talking to Louella. Those seats fill first so she must've been here awhile. Or a chivalrous cowboy got up and gave her his. Her and Salazar had an affair. He's given me his word I'm the only woman in his life. Yeah right, I used to think, he's so good looking. But I believe it most of the time, now I know him better, he's so fucking honorable. Louella isn't why he's up there though. It's high and he can keep an eye on the world.

The palomino in the ring is old and should be retired. People don't do that where hay is eleven bucks a bale and all pasture is irrigated. They try to sell their old horses for a kid rider and if they can't, they get rid of it for poundage. Look at the label on a can of dogfood. It's cow or chicken parts. I've never seen horse meat dogfood. Dogs don't eat horses, people do—in France. I'll never go there. But sometimes it's kinder for an old horse to be slaughtered than ridden hard and abused.

The sale ring, auctioneer's stand, bleachers and balcony are

covered but the sides are open and the wind is cold. I sit and shiver and every time the bony old palomino turns, I get dirt in my lap.

I stand and wave to Salazar and point to the holding pens. He leans against the railing and nods and waves like a brown bishop and I am dismissed. Louella stares at him like she wonders why in the world he left her for me. I asked him that. He said she's boring. With tits like she has, I don't see how.

I force myself to walk down the aisle and look at the horses. And I wonder which ones are biters or kickers or spook or buck or bolt and that's why they're here. Some are just old. I don't like it here at all. But Salazar says it's a good place to feel out the market.

I'm glad I didn't ask Johnny to come, he'd have worried so. The horses have water but no feed bins. I see a paint at the end of the aisle. I've always wanted a paint, a black and white one, like Tom Mix had after he fought in the Mexican Revolution and went to Hollywood. Tony, his name was. This is a brown and white one though. I try to touch his nose and he jerks up and back. Somebody's yanked him around. I hate the people who've brought these horses here.

Salazar tells me the world is a suffering place and he can't hate people for causing suffering or he'd hate everybody—besides, he's caused some himself. Yeah, and so have I. So what? I hate them anyway.

Most people come to the horse sale for the show and to socialize, to look at the horses and talk about the ones they used to have. The perfect barrel horse, could run them there barrels in ten seconds flat. The perfect rope horse they had "back on the ranch," that knew what thet ol' cow was athinkin' afore they thunk it. But one day thet durn geldin' got out on the innerstate, 'cause he's so smart ya know, he could open gates. A diesel hit 'im, kilt 'im deader 'n shit.

All the perfect horses are deader than shit.

Jill walks up to me, velcroed to a hick-looking guy. She's wearing tight russet colored jeans with an even tighter red sweater. The roll of fat above her belt is the same size as her

breasts. She is with a different guy every time I see her. "Which one turns you on," she asks. For a second, I think she means which one of her boyfriends, then I realize she speaks of the horses.

"Oh none. They all look so cold and pitiful."

"Naw, they're okay. They all have their winter coats. This here's Bobby." I smile at Bobby and he leers back and I notice chewing tobacco stained teeth, a front one broken. They move on, two of love's sweet dreams.

I sit on an upturned bucket out in the sun and face away from the horses and the balcony where Salazar and Louella are. I know he sees me. I hang my head like the horses do and pick up a stick and scrape in the dirt meaningless scratches. I feel Salazar tell Louella he'll catch her later. I toss the stick and dig around in the pocket of my jacket and find a paper napkin with dried taco sauce on it. I wipe my nose and feel him walk down the steps.

I stand up and run both hands through my hair to get it off my face, then dust the seat of my pants, then bend over and adjust the tops of my jeans over my boots. I feel him walking towards me. I zip up my jacket and turn slowly to face the sale ring. Salazar is still fucking talking to Louella. Do I care? Shit yeah.

I think about the bicycle tire roll of fat around my middle that wants to mature into an imitation of Jill's. About my dimpled thighs, yellow toenails and hard lizard-skin heels.

A man doesn't worry about body image, what he looks like naked—big gut, gray armpit hairs, pimples on his ass. What he's got hanging makes up for everything else. That's how a man thinks. Louella is ripe. Past being a hard greeny red tomato and into a soft juicy ruby one. She meets a lot of men at Slammers, but I know when she's around Salazar, she's wet to her knees. He's given me his word, but too much temptation can make a man think with his little pink head. And there isn't any room in that head for promises.

So I sit back down on the bucket and wait. When we get back I should look for Johnny. I'll be tired and depressed and I

don't want to worry about him anymore. Oh my brother be near me, for thou art lame and halt. Sometimes I wish he'd die.

I try to move away from thoughts like that so I get up and walk around. My skeleton moves, tied together with strings, flesh softening the hard edges of bone. Soft engine of blood and tissue. One day the alternator burns out, the tank is empty, the pistons stop. The worm dies not, but I will and what will happen to Johnny?

I go to the cook room and get a large cup of coffee. It warms both hands. I walk down the aisle again and look at the horses. The bony old palomino brought $475. He gave maybe twenty years of his life carrying people around and that's the value of his existence. I sip my coffee. It looks like the shit water puddled in the holding pens, but it doesn't taste too bad. Sip, sip, sip. I pour out the rest and toss the cup in a trash container.

Salazar can fucking talk to Louella all day but I don't have to hang loose. I start back towards the pickup. Salazar's the only one who drives it but I have a key. I had it made from the extra one he has in his desk. I never told him, I don't know why. I'm going to leave his ass with Louella. It's only twenty-five miles or so back home. Somebody'll give him a ride. Cops always have buddies wherever they go.

I fumble the key into the lock, open the door and step in. Before I can slam it, Salazar's there holding it open. "Let's go look at the horses," he says.

"Fuck you. You make my monkey dance talking to Louella where I can see it."

"Yes, and I talk to her where you can't see it. She's an old friend. I gave you my word. Hell—monkey dance."

I sigh and get back out. He never asked about the key. Probably he knew I had it.

We go back to the horse aisle and Bobby and Jill are there. Salazar thinks Jill is loose, that's his term, because she used to hang around the back lot at the truckstop. Not selling it, just feeling a little sorry for the lonely truckers.

Bobby has his arm around Jill's shoulders and she's leaning into him with both arms around his waist. "Well, well, look

who's here, Officer Salazar. You gonna buy a horse and be the lone ranger? This here's Bobby."

Salazar is aloofly polite. He nods and shakes hands. Jill says, "So sourpuss, how come you can't ever smile? 'Fraid it'll crack your face? C'mon Bobby, Officer Salazar don't talk to peasants, besides I'm hungry." She winks at me and they leave.

We stand in front of the paint. Sourpuss is a good word. His face looks like he's watching somebody suck a lemon. I say, "Mexicans and Indians like paints, don't they?" He does his Mona Lisa imitation and I know he's not mad. But then, I've never seen him really mad.

The horses stand in their small pens, up to their ankles in slime, some with dried mud on their sides and you know they've tried to lay down. I say, "Okay, we looked at them, I don't want to look any more."

We get in his truck and maneuver our way through the stock trailers and pickups. I sit by the door and stare out the window. We bump through the dirt lot and onto the pavement. The gray brush blossoms here and there with white plastic grocery bags, then strings out into a long blurred line and it's hard to count the telephone poles. I say, "She's an over-ripe plum, Louella is, and I'm the prune." This time he laughs out loud, a short bark, but he's amused.

"Marie. Young and beautiful didn't matter to Prince Charles and it doesn't matter to me. Besides, you are beautiful."

"But not young."

"Young changes every day."

I look out the window at the greasewood flicking by and smile a secret smile. It's the only thing he could've said that was right. So I slide over and pat him on the leg. He hugs me and kisses the top of my head. He asks, "Do you want to look for Jacko?"

"No. Sometimes I wish...."

"Yes?"

"Nothing."

Salazar waits a minute to see if I'm going to say something else, then says, "Put your seat belt on."

I do, then he says what he's said a dozen times before, "Marry me."

"All right, okay. What the yell, yes I'll marry you."

He doesn't do much hard cussing around me, but says under his breath, "So shitfuck what's the catch?"

"After you find the perfect horse."

VI: Jacko

GRANDMA WAS RIGHT, AN EYE FOR AN eye. I got out of bed and walked up the wash. The lowlifes were snoring in their burrows. They crawl in their holes as soon as the sun goes down when it's as cold as it has been.

I waited in the hard black shadows listening to Monk talk to himself. The only time he ever shut up was when he was good and drunk. He had the best house in the camp, a dented and buckled camper shell with a plywood real estate sign pulled over the open end. Some of the other houses were cardboard, which is okay as long as it's dry out, and a few lowlifes had just scooped out a low spot, like an animal, and filled it with rags to make a nest.

Finally it was quiet. I knew he'd passed out and wasn't anything going to wake him up. But still I crept, soft as a whisper, over to his house and laid aside the sign. Monk smelled like moldy, wet carpet that's been peed on for a hundred years—bad enough to gag a maggot. The light was good enough to see he was the only thing in his house. He probably sold Pits's stuff a long time ago.

It felt like the skin on my fingers shrank back to the bone when I touched him, but I had to know. Slow and quiet I pulled Monk out. Then I knelt down and felt through his clothes.

I found the medal stuffed in an inside pocket. Monk hadn't sold it because maybe it made him feel special too. I stood up shivering and felt with my thumb the lady fighting the man and Pits was in my head again talking about the brave and wondrous thing his grandpa had done.

I looked down at Monk and saw his mouth hanging open. Spit dribbled out into the greasy stubble on his chin and down onto his neck. I saw his rotten teeth and the crust around his nose holes and hated him for killing my friend.

It didn't take very long to get back to my place and take apart my old house. I folded up the heavy black plastic and carried it up to Monk's camp. While I was gone he'd curled up on his side and put his hands between his knees, he was starting to feel the cold. I unfolded and smoothed out the plastic sheeting on the ground next to him.

Gently, I straightened Monk out. He was dead drunk and pretty soon he'd just be dead. That was a good joke but I didn't laugh. I rolled him up in the black plastic all nice and snug like a bean burrito. The blue cords off Pits's backpack worked just right to tie together the open ends, except, I left one of his hands sticking out by one of those little squeeze things, like maybe he got cold and tightened it up himself. Then I stuffed him back in his rotten house and put the real estate sign over the end. Probably nobody would look until he started stinking. The lowlifes would find him and drag him away into the weeds. Then they'd move camp further along, taking his camper shell house.

When Sonny Ray got up next morning he looked at the bare yucca sticks of my old house and took his ball cap off and rubbed his head. "I see you're cleaning up the place. Looks a lot better."

After he left, I sewed the sleeve on my jacket that Sonny Ray ripped the other day when we found Pits. It's my favorite coat. I found it laying on the cement thing around a light pole in the truckstop parking lot.

A long time ago my grandma took me to a rodeo and Rex Allen was there riding a beautiful horse named Cocoa. My

jacket looks exactly like Rex Allen's did, except the zipper doesn't work and the ends of both sleeves are a little melted.

I put my jacket back on and went to the truckstop store and snagged a can of cornbeef. Now, I don't hang around and beg off the truckers like some of those lowlifes do. I've never begged for anything in my life. I work to live and I live cheap and sometimes I take stuff that people don't need or won't miss.

Since my place is down by the wash behind the truckstop, I'm close to where people dump all kinds of trash. I find a lot of good things, like one of those red knives with all the little gadgets. Some's busted off but the can opener's still okay.

West past the truckstop is a junkyard and west of that is the lowlife camp. Further west of the lowlife camp is the county jail. The recruits used to walk over for exercise and kick those bums' houses apart and mine too.

My favorite spot to sit and eat and think is under the overpass on the freeway. At the top of the slope right under the roadway is a narrow ledge where it's private and peaceful. So I crawled up there to eat my lunch and think about the pictures one of my trucker friends has hanging in his sleeper. When he put up new ones, he gave me the old ones, and, were they ever pretty. All that skin and hair. I had 'em a long time before they wore out.

Anyways, I opened up my can of cornbeef and, oh man, there was an eyelid with the eyelashes and all. I hoped for sure it was a cow eyelid because cornbeef is made out of cows. But what if, when they were making it, somebody fell into the pot and their eyelids boiled off? Except, if it was a person's eyelid there'd be other parts too, like maybe fingernails or teeth. I wouldn't want to bite down on somebody's tooth and break one of my own.

At first I thought the eyeball was under the humped up eyelid. Carefully, I lifted it up with the screwdriver in my red knife and saw it was only a chunk of meat underneath. The eyelid didn't seem as big as a cow's and the eyelashes were black and long. Sometimes I get to talking to the bullhaulers, asking about where they've been and where they're going. I feel sorry for the

cows all crowded in the trailers and I wonder if they know they're going to die.

I thought about walking back to the truckstop parking lot to see if there were any cows around so I could look at their eyelids but it would take too long and I felt weak and hungry.

Too bad Sonny Ray wasn't around. He knows a lot of things. Like when the recruits from the jail used to come around and kick in our houses and mess up our stuff. Sonny Ray said why not make a couple of fake houses and have our real houses hid a little ways down the wash. We could even leave some of our old stuff laying around like we were really living there. When they kicked the fake houses down we could just go and set them back up for the recruits to kick down again.

It was a pretty good idea, even though it didn't work. One of the recruits told me, while he was kicking in my real house, that he knew we weren't living there because the boxes didn't stink enough. And he knew it wasn't my real stuff laying around because even an old burnout like me has better taste than to use old crap like that. But I'm not a burnout. I don't drink, I never did. Alcohol makes me sick, the army doctor said I was allergic to it. And I'm not real old. I'm not all gray and bald like Sonny Ray. He can remember when gas was fifteen cents a gallon.

Then the recruit asked me my name. I told him and he said, "Jacko, I know you have better taste than to wear this old tee shirt somebody has wiped their ass on." It must've been grease. I always smell my clothes before I put them on and I don't remember that it smelled that bad. Maybe somebody used it after I threw it away. Anyways, those recruits weren't as dumb as we thought.

Well, I didn't know what to do. I hear when you find nasty things in your food you can sue the factory that makes it. But hey, there wasn't anybody to see the eyelid but me, and sometimes people don't believe what I say. Like I used to tell those recruits, I'm not a lowlife, I have my sis who gives me a little money when I need it. I can go to Salazar's house whenever I want. Course I don't go very often. My sis, Marie always wants

me to stay and she won't let me eat outside because she's afraid a bug will get on my sandwich and besides I like being free. I told them all that and they wouldn't believe me. They'd just shake their heads and say, "Jacko, you are a lying old burnout."

Except one day, the recruit who always kicked in my house came over with somebody in a white shirt who walked around and held his hands behind his back. He pushed my stuff around in the dirt with the toe of his black boot and said, "Well, well, well. Seems there is a responsible party who keeps somewhat of an eye on you."

"You mean my nosey sis or her boyfriend Salazar? He's a cop you know."

"Yes, I know."

Then he said to move further away from the rest of those lowlifes and my house wouldn't get kicked in anymore. So I did and the recruits haven't bothered me since.

So I sat under the freeway and felt the big rigs grumbling up over my head. I covered up the cornbeef with my cap so dirt wouldn't fall in it and tried to think what to do.

But I couldn't. I took the cap off the can and looked at the eyelid again. I swear there were wrinkles on it. Cows don't have wrinkles on their eyelids. They have hair. Their eyelids are fuzzy, like old car seat covers. So, if there's wrinkles instead of hair, then how can it belong to a cow?

Maybe it doesn't. Maybe it is part of a person. But I was getting hungrier and hungrier. I couldn't go back to the store, I've already been there once and if I went again, they'd watch me.

All that stuff was fizzing through my head, when I saw one of my friends pull his rig off the freeway and head for the truckwash. I call him Arnie but everybody else calls him Alabama Chicken Choker because he hauls frozen chickens. I asked him once if he ever really choked any chickens and he said the only chicken he ever choked was his own sometimes in the shower. We laughed.

Anyhow, my peaceful time was ruined by having to think about stuff that's not too much fun to have in my head. So I decided I'd walk down to the truckstop and show Arnie my cornbeef.

I started down the slope and my mouth watered because, except for the eyelid, it sure looked good. All those little pink chunks of meat all mixed in with the whiteish fat and that jelly stuff around the edges and, oh man, was I ever hungry. But what if I showed it to Arnie and he laughed or dumped it out? Then what?

Oh the heck with it. I was tired of trying to figure it out.

I went back up to the ledge and sat down and picked out the eyelid and flicked it into the dirt where I couldn't see it anymore. I closed my eyes in case there were any other strange parts in the can and ate my lunch in peace while I thought about those pictures my friend has in his sleeper. Mother was as pretty as any of those ladies. I have a picture of her I carry around but it's so cracked I can't really see what she looks like anymore. But I remember how beautiful and soft she was in her white dress lying in her shining ribbon bed.

The dump behind the cemetery is gone now, but she used to go there and collect the shriveled wreaths. She'd pull the ribbons off and braid them into rugs or sew them together long ways into sheets and bedspreads. Her nightgowns were decorated with the tiny satin rosettes from off the babies' wreaths. The pressed paper flower pots—they use plastic now—were perfect to keep her hair pins and fingernail polish in. Everything in her room, even her, smelled like wet paper and sad funerals.

I stuck my finger in the can and scooped out all the jelly stuff. It tasted okay and there weren't any more strange parts. I dropped the can in the dumpster when I got back to the truckstop and up the road I saw Sonny Ray heading for the next underpass intersection with his cardboard sign: "Will Work For Food."

VII: Jacko

SONNY RAY REALLY WOULD WORK AND he has a few times but he can't do much. I guess people see that so they just hand him money and drive on. It wasn't a very good corner because truckers don't feel guilty about not giving their money away.

Anyways, I walked up and he said, "I gotta go take a leak, hold my sign."

So I did and this lady drove up in a little pickup and handed me five dollars. She smiled and said, "Now don't spend this foolishly." I told her thank you and she nodded and waggled her fingers and drove away.

When Sonny Ray came back I tried to hand him the money, but he pushed it away and said, "Keep it Jacko. Your little-boy-lost smile got you the five bucks, maybe you should work for me." So that was okay. It wasn't like I begged it off her.

So I hung around talking to Sonny Ray about good names for my mouse if it didn't die. I'd found it in the dumpster behind the cafe. Sometimes they throw away whole bags of doughnuts and sweetrolls that are only a little bit stale. But there wasn't anything good, except some almost black bananas. The mouse was laying in something sticky and looked dead, till I saw a back leg twitch. I wrapped the poor thing in a paper

napkin and took it home and made a nice warm nest with a rag in a coffee can. My mouse didn't need a name until I saw if it was going to live. It would be too sad if it died with a name. So I needed a name, just in case.

Then we talked about old movies. Sonny Ray told me about a tape he watched at a buddy's house. He said this awful lady was in love with a married man. He wouldn't leave his family for her, so she boiled his little girl's pet rabbit. I don't know how anybody could do that to a rabbit.

There wasn't much traffic and Sonny Ray looked tired. I said let's leave because we'd been there all day, but he said just a couple more cars because he'd only made six and some change. A van came down the exit and he held up his sign. The dusty brown van stopped and a big lady with a back pack jumped out. She stood with her arms bent and stiff and hands doubled into fists, screaming cuss words and coughing in the smoke from the tires as the van squealed away.

Sonny Ray laughed. The big girl looked at him and spit and wiped her mouth on the sleeve of her black Harley sweat shirt. Then she walked slow and careful over to Sonny Ray and got close to his face and said, "Gimme some money dickhead."

He wasn't laughing anymore because he had to tilt his head up to see her face. He said he didn't have any and she pushed him a little. She was bigger than him and he's bigger than me so before she got in my face I gave her the five dollars I just made.

She raised her arm and her fist was as big as a cabbage. Oh man, I thought, five dollars isn't enough, she's going to deck me. She opened her fist and her fingers looked like those big polish sausages in the case at the truckstop deli. I saw Sonny Ray behind her with his sign raised over his head like he was going to hit her. I don't know what good that'd do, his sign is cardboard and it'd only make her madder. I shook my head at him and smiled at her and that was hard to do with my head scrunched down so far in my shoulders but I did. Her fingers barely touched my cheek and she said, "Thanks for the five, sweet thing, I'm Darla."

She winked and stuck the money in her boot. Sonny Ray

watched her walk down the frontage road towards the truckstop and called her a bitch but not very loud. "Well Jacko your smile did it again. Lookit her go. With that long blond pony tail swinging down, she looks like the back side of a draft horse."

So we walked to the truckstop through the twilight and Sonny Ray went into the store. I went around back to the parking lot. It's always full of trucks and a lot of the drivers are my friends. I knew I could find enough work for something to eat.

Arnie's shiny red Freightliner was there. He keeps the outside cleaner than the inside. I stood on the little chrome step and knocked on the cab door. He yelled who is it and when I told him he unlocked the door and let me in. He said the ladies that work the parking lot are always banging on his door, asking him does he want a date or can they get a ride to the next truckstop. There's so many of them knocking on his door he can't concentrate on all his log books.

Anyways, he was sitting in his walk-in sleeper watching his little TV. I asked did he have anything for me to do. He said he was running empty to Nogales but I could straighten out his bed and pick up all the empty cigarette packs and food wrappers. "Hell of a mess, ain't it Jacko? I think I'll ask the next lady I have in for a date if she'd clean up the place for a little bit extra." Then he snorted and laughed and punched me on the shoulder and gave me ten dollars. He said I could eat my supper in his truck while he did his laundry.

So I made his bed and picked up all the trash and emptied the ashtray. I went and dumped the garbage and bought a hamburger and fries and got some damp paper towels. I wiped down the dash and console.

Just as I finished my supper somebody banged on the door. It was probably one of those ladies Arnie's worried about so I didn't say anything. Another knock and a woman's voice said, "Is there a sweet thing in there that wants a date with Darla?"

Now, did she know it was me or not? The windows are tinted. Maybe she followed me. But she couldn't have because she left the corner first. I didn't want a date but didn't want to hurt her feelings or make her mad, I remembered how big she was,

so I said it wasn't my truck and I couldn't invite her in and she went away.

I sat in the comfortable seat warm and relaxed, and like always my mind floated back to my grandma's house and Mother's voice calling me from the basement. "Johnny, my sweet little John Boy, come down and play. Mommy needs you to keep her warm." Grandma was out cleaning a house and I peeked out the windows to make sure Marie was on the sidewalk talking to her friends.

I walked down the basement steps slowly, shivering, knowing she was going to be nice because she called me sweet little John Boy, thinking of her hands and her lips and her long blond hair creeping over my stomach. I crawled into her bed and she held me like a baby and talked baby talk and took off all my clothes and smoothed my whole skin with both her hands and squeezed my hand softly and petted herself with it and her skin was like satin and the hair below her belly button lay like strands of silk and....

"You still in there Jacko?" Arnie yanked open the door. "What'd you do, fall asleep? Place looks so good maybe I'll get me a date tonight. Here, stuff this shit somewheres," and he handed me a pile of clean laundry.

So I put it away while Arnie shuffled through his briefcase, then I thanked him and said I'd better get on home. "Sure ole buddy, see any likely ladies tell them there's a good looking truck driver with a nice clean sleeper just waiting for a date." Arnie always makes me laugh, he's not good looking.

Early next morning, as soon as it got light, I checked on my mouse. It moved around a little bit so I put a piece of bread by its nose but it wouldn't eat. I lay back down on my blanket and thought about what I was going to do with the day. I wanted to go back to the cemetery and check on Grandma's house but what if they'd already torn it down? I've been going there to sit on that wall for a long, long time, just looking at our old house and wondering about Mother and trying to figure out where my life went. If the house was gone what would I think about?

Then I heard somebody coming. I folded my blankets quick

because it isn't polite to have an unmade bed when people visit. I crawled out of my house and before I could look up Darla said, "Well hello again Sweet Thing, nice place you got here. I've been up all night on my back working my ass off and I'm beat."

Darla didn't look very mean anymore, just tired and dusty. I said hold on and I crawled back in and got a blanket for us to sit on. We sat there for a minute not saying anything because I really didn't know what to say, and then she started to cry. I was afraid to touch her but I put my hand on her arm—I figured I could yank it away if she didn't like it. But she patted my hand and said she'd heard about a hobo camp down by the wash. Well, she must be talking about the lowlifes up the wash because me and Sonny Ray aren't hobos. We have a home.

"I need a place to crash, I promise I'll make it up to you."

She didn't seem as tough but still, if I didn't let her stay she might deck me anyway or go on up to the lowlife camp where Monk was probably still fermenting in his camper shell house. "Okay, my space is in at the back."

She had a hard time getting in the door, being so big, but even on her hands and knees her fat didn't sag. I told her, "Get on over behind the cardboard divider, Sonny Ray'll have a fit if you lay on his side." I thought how surprised he'd be to see Darla in our house, especially if she crawled over him to get out, and I laughed.

"What's so fuckin funny? You laughing at me trying to squeeze into this cockroach hole?"

She looked mean again and I got scared and said oh no, no, make yourself at home and I'd be back later. I went to my favorite thinking spot under the overpass. On the way there I noticed that Sonny Ray wasn't on the corner. He probably wouldn't be until his money was gone. Thinking about Sonny Ray made me think about the movie he told me about. The awful lady must've wanted that married man bad, following him around like Darla was hanging around me.

I thought about Darla calling me Sweet Thing. Nobody ever called me that and patted me on the cheek, not even Grandma.

It seems to me, if somebody calls you Sweet Thing and pats you on the cheek they must like you. And if they follow you around they must want to be with you. And if they like you and want to be with you maybe they love you. Maybe Darla loves me. But if somebody loves you that means they want to marry you. Maybe Darla wants to marry me and I can't support a wife, where would we live? Besides, she called my house a cockroach hole. That's what my sis thinks too, sometimes so do I. Anyways, I want a dog first and, oh man, what if she boiled my mouse?

I almost ran back to my place. But then I figured she'd be asleep for awhile and too tired to do anything. I had time to think, except, I couldn't sit still and do it. So I decided to walk somewheres.

I didn't feel like going to Phil's up the freeway—if he was busy he wouldn't talk to me and if I went down the freeway to talk to Pits he wouldn't talk much either being so quiet and dead. I got out the Medal of Honor and looked at it a long time. Pits's grandpa must've been the bravest man in the world, he died being brave. All's I had to do was hold the medal tight in my hand and I'd be okay. So I walked to the cemetery. The people there are dead too but sometimes I can still hear their voices trickling up through the dirt and slipping from under the dry grass to whisper words in my ears.

When I got there I couldn't believe my eyes. I'd just been here Friday and this was only Tuesday and already two houses had been torn down and hauled off and only the concrete foundations were left. Mrs. Wilkers's house wasn't boarded up so she must still be there but probably she'd be leaving soon.

I put the medal back in my pocket because I felt like I was going to pass out and leaned against the wall so I wouldn't fall over and watched a man carry a toilet out of a house three doors down from my grandma's and put it in a pickup. The other men and their machines were all busy pounding and tearing and stirring up dust.

I wanted to run over there and tell them to stop, stop, don't tear down my grandma's house. You can't do that, it's my grandma's house and my grandma is my best friend and would

do anything for me and I love her and she loves me more than anything in the whole wide world and oh Grandma why did you get old and die?

I ran over there but the yellow plastic tape around a ditch wrapped around my legs and the yellow ribbon snake made me fall and I ripped and ripped at it and the men came running over. And they ran towards me and I could see so clearly their dirty greeny brown uniforms and small greeny brown faces. Their sharp shovels and sticks and the yellow ribbon snake didn't want to let me go but I screamed and tore it off and struggled out of the ditch and ran away.

I ran as far as I could and then I walked fast and then I walked slow. Nobody followed me. I stopped and caught my breath and looked back and they were already crashing things around and making dust again and how was I ever going to find Mother and have my very own dog?

My thoughts got as tangled as those big glops of copper wire Phil has at his scrapyard and Darla was at home waiting for me. Some things are so hard to figure out. I wished I could just wrap Darla in a paper napkin like I did my mouse and carry her away. Except, it'd have to be a pretty big napkin. Laughing got the bad stuff out of my head and I felt better.

All that thinking made me hungry. I figured I'd walk on over to the cafe and spend some of the money I had left from Arnie. I'd go around to the back and maybe talk the cook into making me a fried bologna sandwich with mustard. I pulled the money out of my pocket to make sure it was still there and counted it—three dollars. Then I remembered how giving Darla that other money made her happy. Of course I know love is more important than money, but maybe the three bucks would keep her feelings from being hurt so bad she wouldn't want to deck me after I tell her I better not have a date because I can't support a wife. I guess I was going to be hungry for awhile. So I kept on walking back to my place.

When I got there Darla was sitting outside leaning back against my house. "Boy, I needed that nap." She patted beside her and said sit so I did. She asked me my name and after I told

her said, "For you Jacko, a date won't cost anything."

I smoothed out the bills and laid them beside her leg and told her I'd really like to have a date with her but she was too nice a lady for just a date and it couldn't be any more than that because I didn't have room for a wife and I had to get a dog first.

The big tear running down each one of her dusty cheeks made a tiny railroad track. She crumpled up the money and flipped it in my lap. "I don't need your fucking, lousy three fucking dollars," she said and stomped off.

Later, I went back to the corner to see if Sonny Ray was there but he wasn't. I saw Arnie's Freightliner on the westbound on-ramp. Darla was with him. She blew me a kiss and I waved. When I got back home, my mouse had died. Poor mouse. I had a name all ready just in case it didn't die. Jefferson, I was going to call it Jefferson, after this guy I knew in Nam. He got killed while I hated him for a few seconds. I needed to talk to Grandma bad.

VIII: Marie

FIFTY IS A RIDICULOUS AGE. ONE HALF of one hundred. Coins and medals are minted commemorating fifty years of, say, corn husking or automated snack dispensing machines or perhaps, the invention of nylon hip joints. Ugh. Magnified mirrors are so fucking cruel.

Less is better when you have wrinkles, so I put on my usual little bit of eyeliner and smudged it to make sooty eyelids and that's it. Trying to look younger sucks. All is vanity and vexation as Grandma used to say. I see her face just below the surface of my own. Salazar likes me to look plain and talk like a lady. I got half of it down.

My hair is long and as straight as the fringe on a new throw rug. The color is tenacious brown and occasionally I dye the roots gray for a mature look ha-ha. I don't feel like curling it, that takes too long, so I bend over and it all hangs down and I gather it into a hair scrunchy on top of my head. I'm ready to go.

The compulsion to look for Johnny seldom abates. I am obsessed by images of him squashed on the freeway or some scumbag cutting him for pennies. Today, I'll try the cemetery first.

When I drive by Grandma's house, I ask her to forgive me for ignoring her for so many years. Old people are like ghosts that have had their lives in this world and are on the threshold

of the next. What do the very old think? That if the weather is fine, they'll get up and take a walk with the dog? Only they don't, because their walker won't work in the mud and their dog died fifteen years ago.

Johnny isn't in sight, so I park, get out and look over the wall. He's lying on Grandma's grave.

"Johnny, are you okay?"

"Course I'm okay. I'm giving my grandma a hug."

He gets up and brushes off the snips of dry grass from his clothes and I ask him, "Would you like to come home with me for awhile? I'll fix you a fried bologna sandwich."

"No thank you." He shakes his head, "I don't think so. I have lots to do today."

I almost tell him we're getting a horse or two, but man pre-poses and God disposes so I say instead, "Do you need any money?"

He fidgets with the buttons on his coat. It has a broken zip-per and he's made crude buttonholes and sewn on mismatched buttons. He doesn't answer and I know he wants me to leave because he's visiting with his friends. I smile and give him a box of granola bars.

"Thanks. Oh thank you Marie, apple cinnamon, my favorite kind."

He opens it and puts the granola bars in his pockets and gives me back the empty box. "You won't throw it out the win-dow, will you?"

"Of course not, I'll take it to the truckstop and put it in the dumpster."

Johnny nods and I choke back my usual nagging plea and get in my car. I shouldn't have told him I'd throw the box in the dumpster. I wasn't thinking. When he gets back to the truckstop he'll look in every dumpster until he finds it. I have nothing to do with my day but drive to the truckstop to throw away an empty fucking granola bar box.

Arizona is supposed to be warm and sunny, but it seems like it's been cold and windy forever. I crank up the heater and think about Johnny lying on a cold grave. I think about Johnny's

mother, the execrable Ellanor. I hope she's lying in a cold, cold grave. When I was twelve and bigger than her, I hit her in the face with a Barbie doll. I can't really remember what for…it had something to do with Johnny, I'm sure. And a few years later, I left him with that…thing and hit the streets, not as bad then as now. Hard drugs weren't as available and marijuana wasn't near as strong. I found a protector, an old dude, I thought at the time, but tough, in his late thirties—me in early teens. Gene, his name was.

He'd hold up convenience stores when he got low on dough. I was never involved in the holdups beyond knowing about them and spending the money. Even at that tender age, I thought it too much risk for the return. I told him that and he said, "One of these days, I'm going to hit a bank maybe, and then we'll get that ranch in Texas and you can have all the horses you want. Besides, I get a twelve-pack every time, that's something ain't it?"

Gene used a rusty .38 with a loose cylinder. I didn't want to shoot it because it might blow up. He dealt guns on the side, mostly stolen, but wouldn't use a good one himself. He said if he got nailed, the cops would take it and why give them a good piece. He was right. When he did get nailed and had to do hard time, I sold his inventory, except for a .357 magnum. Dirty Harry is one of my favorite movies. Clint's pistol was a .44 magnum. Gene didn't have one of those. Then I drifted and kind of forgot about Johnny and Grandma.

I drive around back of the cafe, put the car in neutral, pull the emergency brake, hop out and throw the granola box in the dumpster.

As I pull around the corner of the icehouse, I see Rosario's black Corvette parked at the end of the last row of trucks. He's doing business. He doesn't deal mingy amounts on the street or carry the product with him, marijuana stinks. Most of his business is wholesale and what gourmet smoke he handles, his boys shrinkwrap before they roll it onto the street. They're all cousins or some kind of relative. The rule is: you never rat on blood, not ever.

Just looking at his Vette makes a humming bird fluttering in my chest and my face feel warm. A hot flash or a burst of old flameitis? I back around the corner of the icehouse and wait. During my drift time, I met Rosario. Part of his appeal was he had horses. I met Salazar then too, but we didn't hang out with him, he was too young. Loving Rosario shaved the thorns from my heart and I went back to Grandma and Johnny. Rosario and me, we did okay—never did get busted.

Presently, he steps out of a blue Kenworth. The first thing I notice is, he's not wearing his crucifix on the outside. He's trashed somebody or about to.

Have you ever seen someone die? It's not like in the movies, they don't die instantly, they struggle and flop, every bit of their energy goes into not dying. And the man's last words aren't anything noble. He says, "Oh shit," because of the terrible unfairness of losing his life to another man's whim. And you stand by and feel his life leave. And you look up and away from the dying man and your eye tries to see that which your heart feels, the Lord come to lead them away and you can never take back what you did and for awhile it doesn't bother you because of the excitement of the next deal.

But one day, pushing your cart through Walmart or taking a shit, you think, I have set myself apart from the tribe. Once that thought is thought you enter from the sun the house without the door, doom. And you can think Lazarus come forth, every time you see in your mind's eye the man's face and his twitching, manicured hands, but the man stays dead. Forever.

Salazar thinks he saved me from a life of crime. I knew though, I had to get out or perish, so to speak, emotionally, and at the time he was a socially acceptable reflection of Rosario. I have discovered he is nothing at all like Rosario.

Rosario sees my car. Did I think I was hiding? And I look like a mule skinner's woman. I have phlegm in my throat and I want to hawk and spit, too late now. What an idiot you are Marie. You'll have to tell Salazar you talked to Rosario and feel like a kid, awkward and uncomfortable. And Salazar will sit there like your young father and ask how Rosario is getting

along. It doesn't bother Salazar, he trusts Rosario.

I get out and lean against my car and fill my eyes with him as he walks across the lot towards me. Long hair so black it glitters, a touch of gray in one long tight braid hanging by his ear, the rest pulled back, blue shades, and earrings—a diamond stud and a gold loop. His clothes are gunfighter chic, a collarless black-and-gray vertical-striped western shirt, black leather vest to conceal his .45, tight Levis, black high-heeled cowboy boots. Booted, suited, and ready for war. What the hell, he knows who I am. I turn and spit.

He puts his arm around my shoulder and gives me a side body, brotherly hug. The cold wind pushes him into me and for a little pinch of time, we are one. He releases me. "So love, que paso?"

"You have another earring hole."

He touches the diamond stud and looks at me out of the sides of his eyes. "Daring, isn't it?"

"And your crucifix?"

He pats his chest. "Under my shirt for awhile. It's more than a piece of jewelry you know."

"I know." He thinks if his crucifix is under his shirt, God doesn't know he's smoked a man down. But sometimes he hides it when he only thumps on someone. There's a scab on the top knuckle of his right hand and I am comforted. "You could get AIDS hitting someone in the mouth bare fisted."

"It's easy to die, love, one way or the other." He lifts his hand and makes a fist. "Maybe you're right—gloves would be cool."

Then he asks when is Salazar getting a horse and start roping again. I tell him about the horses we've seen, which aren't many because we've just started to look.

"Salazar's been looking a long time. Every time he sees a horse he likes, he asks about it."

I shrug and pretend like I knew that, but hadn't expressed myself exactly. "You still have all your horses?"

Rosario closes his eyes and lifts his face to the sun. The diamond in his ear lobe sparks and he is an Aztec prince. He

smiles and rubs his palms on his thighs. "Till death do us part. I've offered Salazar one of the best, but."

He takes my hand and holds it against his cheek. "You always were my main mama."

"There were others?" I can joke about it now.

"You better go. Don't worry, it's a friendly deal. Remember what the announcer used to call me and Salazar at team roping?"

I remember. Rosie and Sally and the cowboys would laugh. He turns and strides away, barbarically confident. He carries my past and I don't want to let it go. That's the thing about the past, it doesn't stick around.

I open the door to my crappy, crummy-little-red-piece-of-shit car. I stand for a minute and the cold wind blows Grandma's voice all the way from the cemetery and it hurts in my ears, "Oh mighty Caesar! Dost thou lie so low? Are all thy conquests, glories, triumphs, spoils, shrunk to this little measure?"

Fuck.

IX: Jacko

SONNY RAY CAME HOME WITH A trash bag of frozen dinners. He said a trucker gave them to him because it was part of a load that melted. We scraped all the food out of the cardboard trays into a pot and made a Mexican, Oriental, Italian stew. Then I put the empty boxes and trays in the trash bag.

After I ate I met Syd at the top of the westbound on-ramp. He wanted some company while he tried to get a ride back to England. He made it to Salt Lake once but he always somehow winds up back where he started.

Even in the winter in the desert it gets hot sometimes in the sun. So after we'd been standing there for awhile with our thumbs out and no ride, we went to the truckstop deli for an ice-cream cone. I got a double dip. I guess I didn't lick it fast enough because when we got back to I-10 the top story of my cone fell off onto the pavement. I squatted down in the gravel and tried to suck up the biggest lump before it melted. Then Syd yanked me backwards so this pickup wouldn't run over me. Licking ice cream off the freeway can kill you.

I rolled down the embankment and lay on my back and the empty blue sky felt heavy on my chest. After a minute I could move everything and nothing hurt very bad but my ice-cream

cone was gone and it was napoleon, my favorite kind. The white, brown and pink stripes are like licking on a rainbow.

Rising up too quick made me dizzy. Instead of spots, I saw thin yellow wire crisscrossed behind my forehead. The wires went away after I stood real still and squeezed my eyes shut. I took a deep breath and when I opened them I saw Jefferson, the guy I was going to name my mouse after.

The sun was shining bright so I couldn't figure out why he looked like he did. He was in a shadowy place that I felt but couldn't see. I used to follow Jefferson around, but he never really liked me. He made fun of my name and everybody laughed. Except, I was still glad to see him. "Jeez Jefferson, where've you been?"

He looked at me like I wasn't real. And, oh man, I remembered what he looked like the last time I saw him, blood all mixed with mud on his white face. And now I think of it, he'd been three colors too. Same as napoleon, just brighter.

There wasn't any blood now. His mouth opened, but nothing came out and he moved away and away until he was only a dark speck in the corner of my eye.

Syd finally made it down the embankment and I told him everything was okay. He said, "I'm jolly glad to hear that old boy. Standing on your ice-cream cone, don't you know."

I picked it off the bottom of my shoe and it was smashed full of grass stickers and little rocks. I put it by a black ant hill so it wouldn't go to waste.

Syd's real name is Sydney Sedgewick-Smythe, but I call him Syd. I asked him, "Did you see a big football player-looking guy with short blond hair on your way down?"

"No. Can't say as I did. Perhaps we should get along back up the embankment or I'll never get a ride home."

He was on his usual way to England to get back to his castle. They took it away because he wouldn't fight in a war he didn't believe in. The last war I heard of was in some place with sand. We killed a lot of people over there because they attacked our soldiers with shovels when we tried to take their oil. I found a magazine in the dumpster. There was a picture of a

white horse lying dead in a puddle of bloody pink water. Its bottom lip hung away from its teeth and I remembered how soft is a horse's nose. How could they do that to a horse?

But that war happened not very long ago and Syd was too old to've fought in it, with his wrinkled face showing through mouse fur whiskers. Anyways, he said his war was the War of the Roses. I never heard of that one. It must've happened in one of those little countries where people don't matter enough to get on TV.

So we went back on up the embankment. I try not to let bad things in my head because they're so hard to get out, but I had to think about Jefferson. For a minute, I thought maybe he wasn't really dead and was just walking along the freeway looking for good stuff like I do.

But no—I was holding his hand when he died. He cried for his mama. I told him she wasn't there, but I'd wait with him till she came. I don't know if he heard me, the whuff, whuff of the chopper was so loud, but I hope so. Except, it seems to me if Jefferson was a ghost Syd would've seen him too.

Syd isn't interested in much of anything but Dead Fish By the Sea, where his castle and serving wenches are. Only, there's lots of ghosts in England, so I asked if he knew anything about 'em.

"As a matter of fact Jacko, I do. Have one in the manse. She drives staff bloody bonkers by hiding under beds and grabbing ankles. Didn't mind her grabbing mine—ankle that is—pretty little wench."

"Why is she a ghost?"

"Dead, don't you know."

"Did everybody see her?"

"Actually, no. I don't think Mater ever did. Even though she would pretend so. Bit odd that, not seeing what others do."

That was something to think about, and it didn't seem like Syd was going to get a ride. Maybe he couldn't get one because of the way he looked. Pieces were falling off his aluminum foil vest. He'd cut the bill off a ball cap and covered it with foil too. He made a lance out of a yucca stick taller than him. A yucca

stick is scary looking even though it's hollow and the wood is light and stringy.

I told him people might think it's crazy to be carrying a long stick and besides if he got a lift in one of those little cars it wouldn't fit. He said he wasn't ever giving up his lance because he might have to use it on a Tudor, what ever that is.

Anyways, after rolling down the embankment I didn't feel so good. The heck with it—Syd didn't want to stay either. So we went to the truckstop cafe. Rachael used to be a waitress but now she works in the kitchen because she has warts on her face and people said it took their appetite away. I don't mind Racheael's warts because she's my friend. I wait sometimes by the dumpster by the kitchen door and she gives me stuff to eat that people have sent back. Eggs are best. Customers send them back because they're too runny, then the cook gets 'em too hard and they don't get eaten. I like hard fried eggs.

Rachael hops around like one of those little birds pecking stuff off the parking lot and I like to watch her move. When her fluffy red hair's tied back, gray hairs stick out around her face.

I asked her once how she got her warts and she said, "I let somebody kiss me I thought was a prince but he was really a toad in disguise." Then she cried and said that was a joke and they weren't warts, they were something else but I forget what. She lives by herself at the Do Drop Inn motor court on the old highway. It's kind of on the way to the cemetery and she walks back and forth to work and says that's how she keeps her girlish figure and that's right. She has got a girlish figure, but I think she walks because she can't afford a car. I thought at one time she might be my Mother, just dyed her hair red, but she's not because she's nice to me all the time.

So Syd and I went to the cafe and Syd called her a wee bonny lass—I thought that's what they called pretty ladies in Scotland—and she giggled and called him a real gentleman and gave us the doughnuts they hadn't sold in a while.

We sat in back on the shady side of the dumpster. I asked Syd why he had to get back to England so quick. He sighed and said something about landowners can't be away from their land

adventuring too long. "I really must get back to England. I'll rest a bit, then be on my way. I say old boy, there's two jellies, won't you have one?"

The white sugar on top of the brown doughnut felt like fine sand on my teeth. Sticky red jelly dripped out and ran down my chin and while I chewed I saw Jefferson again. He tilted his head back and squeezed his face up like he always used to do when I did something he thought was funny. Except, all's I heard was an echo of laughter.

When I was real little, before Mother would take me to bed to keep her warm or to punish me, she'd sing an old song in a soft sweet voice: "Have you seen the ghost of John? / Long white bones with the flesh all gone. / Wouldn't it be chilly with no skin on?" And I'd be so scared. But Jefferson had all his skin on and regular clothes and that was funny because the last time I saw him he had on cammos. I could see him now, plain as I could Syd.

Syd licked his fingers and I said, "D'you see that guy over there by that stack of tires, it's the same guy I saw up by the freeway?"

Syd grabbed his yucca stick propped against the dumpster and hollered, "Mind yourself, it may be Sir Owen!" Doughnuts went flying and Syd tried to catch them and swing his stick and get up all at the same time. By the time he got himself straightened out Jefferson had gone.

"Is the knave still about Jacko?"

"Didn't you see him?"

"Can't say as I did old boy. Doesn't surprise me in the least though. Slinky lot are the Tudors."

Anyways, now I know the Tudors are people. I didn't bother to tell him it was Jefferson not Sir Owen. Jefferson used to always laugh at everything. And I've thought about it so many years, I know now he didn't just laugh at me. I wished I would've understood that then. He'd laugh and say "Alert, that's me. Ain't no slope going to sneak into my shit." But they did. The last thing he said to me when he jumped into his jeep was, "Later, Jackoff." I only got to hate him a few seconds before

he drove over a mine.

I told Syd I'd keep him company again until he got a ride. By the time we got back to I-10 the bright edge of the sun going down made the tops of the mountains across the freeway look like they were on fire. Syd'd get a lift now since I talked him out of wearing his armor. I told him he was just advertising to Sir Owen that he was Sydney Sedgewick-Smythe.

"Too true, Jacko. Perhaps my journey home would go quicker if I traveled incognito."

But I couldn't talk him out of carrying his stick to the freeway. He said he'd leave it laying in the weeds in case he needed it, but wouldn't take it when he got a ride.

Syd stuck out his thumb and got busy watching the road so we didn't talk much. I sat and leaned against the leg of a highway sign and thought about the friends I used to have. Some's dead and some's gone. Grandma was my friend. She's as gone as Jefferson, as gone as Syd's going to be. They all go. But maybe sometimes, they come back.

Everybody must be stopping for supper because there wasn't a lot of traffic. It was getting on to the gray time of day when things are hard to see, and the air feels thicker and I hear far away sounds and the night critters are rustling and waking up.

Car lights came on and I'd watch them head towards me when whuff, they went past. Another, then whuff. Whuff. For a second, for part of a second, I thought Jefferson walked across the pavement out of the fiery mountains towards me.

Only it wasn't Jefferson. I saw that when I stood up and he got close. Just a hitchhiker with a back pack and holding a cardboard sign that said: "San Antonio." When I caught my breath, I must've read the sign out loud. "San Antone."

Syd yelled, "Sir Owen! Found me out again, eh?" And pulled his lance out of the weeds.

The hitchhiker was big and young. He looked at Syd swinging his stick and shook his head. "I only wanted a smoke, fuckin' old psycho," he said, and went back across the freeway.

I told Syd, "Okay, okay. It wasn't Sir Owen, just a guy wanting a cigarette." But Syd wasn't listening. He still swung his

stick slow and wobbly, like a spinning top run out of steam.

I got hold of the stick just as he started another swing. He wasn't as wobbly as I thought. It pulled me in front of him and I would've gone down the embankment again, except I grabbed onto the leg of the highway sign. I threw the stick further away, back in the weeds. That got Syd's attention. "I say Jacko, I believe the blackguard is gone."

Well, that's what we were discussing, when a flatbed loaded with pallets of Mexican tile stopped. The driver leaned across and said something in Spanish. We shook our heads because we didn't understand. So he pointed west and said, "Casa Grande."

I told Syd, that's on the way to England. He tried to open the cab door, but it was caved in and rusted shut and he couldn't. The driver grinned and jerked his thumb towards the back.

Syd shook my hand and thanked me for my hospitality. He turned to climb up and I remembered I never did thank him for pulling me out of the way of that pickup. So I did and he said, "No need to thank me old boy, I had no hand in it. I was watching a pretty little wench in a gold convertible. I thought you slipped in the gravel and fell backward. I say, cheerio." He gave a little salute and the truck pulled away.

So if he didn't pull me backwards, who did? Maybe I did slip in the gravel.

The next day I took my bag and walked the left shoulder of the eastbound looking for good stuff. Mostly, I pick up cans but sometimes there's clothes, and once, I found a big wrench a trucker gave me ten dollars for. Except, I'm careful about kicking open tossed bags of garbage because of the used paper diapers.

The wind got cold and the morning sun got hot and sweat stung my eyes. I took off my jacket and tied the sleeves around my waist. Hardly anything was in my bag, but it got awful heavy and those thin yellow wires burned again behind my forehead. It hurt bad.

I needed to get in the shade and up the road just ahead

where there was a square concrete culvert. I don't know how I made it. I can't go easy into holes anymore so I sat out of the sunshine just at the edge of the darkness.

The square of light at the other end of the culvert filled up my head. Cars and trucks going over sounded far away like my brain was wrapped in cobwebs. I closed my eyes and looked back down through myself and saw a tangle of veins and gristle and the yellow ribbon snake wrapped round and round my guts.

I don't know how long I lay curled up in the dirt against the cold concrete when somebody said, "Yo, listen up."

At first I thought it was Syd, but he doesn't talk like that.

"You're following me around again."

No—the voice wasn't Syd's. Besides, he was on his way to England.

Trying to open my eyes was like trying to open the window in Grandma's basement after it rained. The wooden frame would swell and stick and I'd push and push and finally it'd fly open just like my eyes did.

Jefferson stood in the shadows laughing again. The words floated out of his mouth on silver moth dust, "Only dumb fucks and lizards go out in the noonday sun, even in the winter."

And, oh man, was I happy.

I sat up and the cobwebs on my brain shriveled into the bright desert. Silvery dust settled over my open hands and as I strained to see his face the yellow wires behind my eyes faded away. Inside the powdery darkness Jefferson began to drift away. I cried, "Jefferson, don't go."

"I'm not going anywhere. You are. You're going back. I'll be here forever." I guess I'd been holding my breath, when I let it out it blew his laughter through the tunnel. "Later, Jacko." And he was gone.

X: Marie

THE SHOP VAC IRRITATES ME. EVERY time I move it, it falls off its wheels and tips over. I get the duct tape and tape the wheel base to the cannister.

I pull the Rubbermaid containers out from under the bed and put the extension tube on the sucker upper. By reaching under from each side, I can capture the dust balls and dead bugs in the middle. All the containers but one are filled with Salazar's mementoes—notes from the academy, a lucky pair of cowboy boots, and all of Fido's toys, his collar and dishes.

When I moved in they were all over the place, full of and covered with the dust of ages. I cleaned everything up and put it away and he's never looked at it since.

The dark green container has my stuff in it—some of Grandma's things and pictures and memories and assorted pain from the past. Why do I keep shit like this? Why does anybody? Even the souvenirs of happy times make you sad because they happened long ago and far away when you were immortal.

I open the container and shuffle through the loose photos. I hold a small black-and-white picture of a young, smiling Grandma standing proud in front of the brick high school where she taught English. She told me when she was dying, "In all my days, I never thought I would end like this, helpless and

feeble." In the picture, she looks like she never would ever.

At the very bottom is an envelope. It contains two photos, one of Johnny's mother and one of her and our dad taken before Johnny was born. When my dad died, Grandma's heart died. The only thing that kept her going was Johnny and me, making me read and Johnny think.

I still have the memory of how much I hated Ellanor, but all I feel now is a vague hope that her life turned to shit after she left. I had my spot of revenge though. I told Mrs. Wilkers Ellanor was messing around with Mr. Wilkers.

I used to go to the cemetery and skate. It was the only place nearby with sidewalks. Ellanor was in the dump behind doing her usual ghoul shit, picking through the dead flowers for ribbons. She pulled a long pink one off a wreath, rolled it neatly, put it in her bag and headed for the crematorium.

Sneakers hadn't been invented then or Grandma couldn't afford them because I had shoes with soles and an antique pair of roller skates that needed a skate key to adjust the side pincers to the rigid soles of my shoes. I'd left the skate key on a bench and I didn't want to go all the way back for it. Have you ever tried to roller skate quietly? I skated opposite the window then walked in the soft dirt and that wasn't easy on roller skates. I had to see what the bitchcreep was doing, I just had to.

The blinds were closed, but by leaning around a bush and peeking through the edge of the window and under the shade, I could see down the hallway into the coffin display room. Ellanor must've been a quick change artist because she had on a white dress and that wasn't what she wore into the place.

Mr. Wilkers wrapped her hands and feet round with pink ribbon while Ellanor stood there like she was in a trance. Then he picked her up and lay her in a coffin of polished dark wood with brass handles, lined with lavender satin. He lifted up the skirt of her long white dress and draped it over his head. My view was restricted because of the angle of the doorway and it was getting good. I leaned around the bush straining to get a better look and my roller skates rolled out from under me and I fell and scraped my forehead on the window sill. That scared the crap out of me.

If they caught me spying, I thought, they'd stuff me in the corpse oven or tie me up with pink ribbon and stick me in a coffin and nail down the lid. I got the hell out of there quick.

For a little while after, it was kind of fun imagining what they did, because coffins aren't big enough for two. I knew about missionary position sex, but not so much about the kinky kind and my thoughts became wormy and the fun disappeared. What came into my mind when I saw Mr. Wilkers ever after, was maggots. The maggots made me tell Mrs. Wilkers what I'd seen. All she said was, "Oh dear."

I gazed at Grandma's picture again. What happened to the space between then and now exists only in mine and Johnny's head and maybe Ellanor's if she's still around. I doubt there's much of anything going on in old Mrs. Wilkers' head. I drop the pictures back in the container, jam on the lid and shove it back under the bed. Ah well, time crumbles all the cookies of existence. When Salazar gets home, we're going to Douglas to visit his great-uncle.

We drive east on I-10. The semi-truck traffic is heavy. We're doing seventy-five and they blow by us at ninety, some of them anyways. The company trucks keep it down. Then there's always the mint-condition, four-door sedan from Nebraska or Illinois driven by an oldie and, as ever, a tiny white-haired wife beside him, creeping along at fifty-five, going where? The lemmings of I-10. Do they keep driving east or west until they splash into an ocean?

Tio Ha-Ha's ranch is outside Douglas, close to the Mexican border. Uncle Ha-Ha. Salazar can't remember when or why he started calling him that. His real name is Faustino. The rose bushes his long-dead wife planted in front of the small adobe house are leafless and tremble in the wind. He opens the blue painted door and two small dogs rush out, yapping and pretending they're tigers. Tio Ha-Ha comes out onto the porch and greets Salazar in Spanish and they kiss each other on the cheek. I get a hug, then he admonishes the dogs and they sit and pant and wag their tails.

His white bandit mustache is neatly trimmed and he has on a white long-sleeved shirt and creases pressed into his Levis. He is Salazar forty years from now. "It's been too long. Have you eaten?"

"Are you kidding," Salazar says, "we drove all this way for free food."

"I had Adelita make an extra dozen tortillas for you to take home. She couldn't stay, she had to get back to her old mother."

The house is warm, heated by the black iron cook stove. Two cast-iron pots steam on the back. Tio Ha-Ha takes our coats into the bedroom that opens directly off the kitchen. A Catholic Church Extension Society calendar hangs on the wall by the bedroom door. The picture for this month is The Resurrection Of Christ.

We sit on mismatched wooden chairs all painted different pastel colors, grouped around a light green enameled table. He pours coffee into thick mugs already placed on the table.

"Adelita's work," Tio Ha-Ha says. "How do you like it? I think my kitchen now looks like Pancho Villa's ice cream parlor, no?" He laughs. "Pancho loved ice cream. Perhaps his ghost still goes to the Elite Confectionery in El Paso."

Over the fireplace is a group photo of Villa standing with his brave young men, with bandeleros and rifles and stern, fierce faces. Villa's eyes squint at me through the dust stirred in 1914. He didn't smoke or drink, but liked women. He survived the revolution only to be assassinated in 1923. When they dug up his body to move it to a safer place, his head was missing. It's never been found. Perhaps there's a shrine, hidden in a mesquite bosque where Tio Ha-Ha goes to light candles around Pancho Villa's mummified head. Sorry Pancho, no need to look at me like that. Every July 20th, Tio Ha-Ha brings a flower to your statue in Tucson and if the 20th falls on a Friday, he brings two.

And okay, I understand a little of what it means to be macho, the quiet arrogant pride of being a man. After all, I live with a Mexican—who isn't at all like the gringo boyfriend I once had who thought he was macho man. He drank a lot of beer, talked loud and cussed the government. And, oh yeah,

knew all the football scores. But for all that, he picked me wildflowers in the spring and told me about his day.

Salazar scrapes his chair back, "I came here to eat." We all laugh and crowd around the stove, dogs and all. There's beans in one pot, red chili in another and placemat-sized tortillas in a pizza pan covered with a cloth. He fixes me a burrito and slops on some beans, hands me the plate and starts on his own.

Tio Ha-Ha fixes a burrito apiece for the dogs and tells them they have to wait until it cools down. They stand on their back legs and hop like miniature brown-and-white kangaroos.

Salazar eats half his burrito before he speaks, "Umm, umm. I know you didn't cook this. When are you going to make of Adelita an honest woman?"

Tio Ha-Ha keeps his eyes on his food, he's thinking he could ask the same question back. He looks up and says, "When her mother dies, if she doesn't outlive us both. She has now a hundred years and slipping a little, no? She has it in her head, she named Adelita after the most famous *soldadera* of all the women who fought with Villa, and maybe she did. But she says also, no, that she rode with Villa herself. *Quien sabe*, who knows. It is perhaps only a horse dream."

He speaks softly and in a different voice to the dogs, baby talk, and gives them each their burrito. They tear into their food and, of course, it goes all over the floor. He laughs and calls them little pigs. They lick up what they spilled and he picks up the plates, puts them in the sink, wipes up the dog slobbers and says to us, "There is yet enough light to regard the horses."

It is ritual, every time we visit, we must look at the horses. They're in the lower pasture along a wash lined with mesquite trees and thick brush. Tio Ha-Ha whistles and claps his hands and calls, "Sonya, we have company." The old white mare ambles out of the brush leading a herd of six other horses. They all come to the fence and he digs in his pocket for sugar cubes. "These are bad for their teeth, they only have sugar to entice them out of the brush."

They all stretch their necks and nicker softly, gentle begging voices. The boss mare, Sonya, lays her ears back and nips the

bay next to her on the neck. It's a real juggling trick making sure each gets a treat. "They are beautiful, no? A good wet winter, there will be much grass."

Salazar points out a seal-brown gelding. "He is quite elegant, almost like a Paso Fino."

"Ah *si*, he was bred in Mexico, but no Paso Fino. He will be Adelita's when she comes." He strokes each horse on the neck and blows his breath into one of Sonya's nostrils. "Horses like to smell your breath, I don't know why." She flares her nostrils and takes three short breaths but doesn't stand still for long. Her back leg is cocked, ready for any other horse that gets too close.

When we reach the house, the dogs greet Tio Ha-Ha as if he's been gone for days. He lights the paper and twigs previously set in the fireplace and when it fires up, puts on the heavier wood.

Me and Salazar sink into the high-backed couch and Tio Ha-Ha brings coffee, then sits on his wing-back chair. All the furniture faces the fireplace and Pancho Villa. There is no television. One of the dogs jumps on my lap. I never can tell them apart. One is Peso, the other Centavo—both answer to either name. His hair is silky as a child's. I pet his little head with my thumb.

The talk is of horses and the Mexican Revolution. Tio Ha-Ha's father was a dynamiter with Villa's Division of the North. He was with Villa when he entered Mexico City and met with Emiliano Zapata. The past, present and future blend together into a soft nickering. The little dog on my lap is warm and comforting and I'm warm and fed. I drift off. *The heat is a weight, bowing heads of horse and man alike. My nose is clogged with dust but I smell the sweat and blood of the wretched horses, some horribly wounded but still carrying men and goods.*

Adelita rides beside me. Her hair is gray, almost white and twined into a single long braid that hangs over her shoulder and across her breast. A dirty pink ribbon is tied round her waist. Her horse is thin and mangy. She wears two revolvers, one at each hip and bandeleros lie slung over the saddle in front. A rifle in a scabbard is tied to a brass ring. She says, "My

man was killed in the fighting this morning at Agua Prieta. To-
day I mourn, tomorrow, I lie beside another."

I ride beside her on a black-and-white paint that prances so
daintily I don't feel its gait. I say, "It is such a shame my pretty
pony will die and the ravens eat him, the horses suffer so."
Adelita touches my shoulder and I start to slide off my horse. I
am falling—my arm flies out and slaps the couch cushion.
Frightened, the little dog leaps off my lap and onto Tio Ha-Ha's.
He and Salazar laugh. I say, "I'm really thirsty."

Salazar jumps up as if my thirst is so extreme he must carry
me to the water faucet. "No, no," I say, "I'll do it, I need to get
up anyways. Too much chili."

I go to the kitchen and rinse out my coffee cup and fill it
twice, gulping down the cold well water even though it hurts
my teeth. Salazar comes in, stretches and pats his stomach. "We
better go before I fall asleep too. I'll go start the truck."

The dog has forgiven me for frightening him and both have
followed me into the kitchen. I pick up each one and kiss it
goodbye. In the living room, Tio Ha-Ha stands staring into the
fire. I thank him and hug him till the next time. He says, "You
were so quiet, no? Your brother is much on your mind?"

"Yes, much."

"I hear they are tearing your grandmother's old house
down. Perhaps this has unsettled his mind?"

"I'm sure. If only he would come home."

"Home? *Si Dios no quiere*, if God does not wish it...."

Salazar comes in and he and his great-uncle embrace and
pound each other on the back. They stand apart and the old
man says, "You will return soon, no?"

"Soon, yes. Give our regards to Adelita and Mama
Soldadera."

We walk to the door and they shake hands. Neither wants to
leave the other. Leaving the warm, lighted house and stepping
into the cold wakes me up. The wind has died down and the
sky is so bright and crisp with stars it seems to crackle.

In the pickup Salazar says, "Sit next to me."

"There's no seat belt in the middle."

"Just until we get to the pavement."

He pulls me into his chest but the dirt lane is too bumpy to hold the position. He strokes my thigh, long and slow like petting the neck of a horse and I know what's going to happen later no matter how tired we are, although languid and lazy is good too.

We make it to the pavement and I slide over next to the window and put on my seat belt and ask, "What's a horse dream?"

Salazar waits a second collecting his thoughts. He loves his great-uncle and doesn't want to speak with disrespect. "The dreams of the very old are as vivid as the dreams of children. Tio Ha-Ha expresses everything in relation to horses. They are always there. One dies, he finds another. His grandsons break them for him now, but he watches and sees himself. Genetic memory maybe. It keeps him forever young, *Comprendes Mendes?*"

A long speech for Salazar with a little joke at the end. Must be the joyous anticipation of the delights to come after we have wended our weary way home. I reach across and put my hand in his lap. Oh yes.

I lean my head into the nook between the seat back and window glass and think about Adelita in her pink ribbon. When she comes to Tio Ha-Ha they will bridle and saddle their pretty ponies and ride sedately up and down the lane and he will be a fierce young fellow, his *soldadera* by his side, riding with the Division of the North, thundering to war at the right hand of Pancho Villa. Horse Dreams. What the heart wishes but the body cannot do.

XI: Jacko

I DON'T REMEMBER WALKING BACK TO the junkyard but the money I made from the cans was enough for a napoleon ice-cream cone. The weak sun had warmed the curb outside the deli so I sat there and watched people getting gas at the pumps in front. A fat lady tried to squeeze out the door of her Ford Escort but she'd parked too close to the pump and couldn't. She backed to the other pump and went in to pay and bought a giant diet Pepsi. She sat her soda on the roof of her car, pumped her gas, got in and drove away. Her diet Pepsi fell off and splashed on the pavement. She glared at me as she went by like it was my fault.

I ate my ice cream and thought about all the things I should've said to Jefferson. I could've asked him if he'd seen Mother. After all, if she's dead too he might've seen her around.

Presently, I felt better. My grandma used to say presently and by and by and perhaps. She'd never let me cuss or say ain't. I don't know what happened to my sis.

By and by, I got up and went to the showers. It only costs a couple of bucks. I'd do it while I was here and change into clean clothes for the party tonight. When I came out of the shower room, who did I see but Skipper walking towards the wash. No one likes Skipper. I don't like him either, but I talk to

him sometimes because I feel sorry that nobody wants to hang out with him. But I wanted to get myself into a party mood and if I talked to him I wouldn't be. He's always talking about how he should kill himself and make everybody happy—that and women.

So I ducked around the icehouse and pretended I was invisible and it must've worked because he didn't see me. I bet he would be at the party. I hung around the icehouse and watched a short Mexican guy in black rubber boots blow ice on top of a load of produce, then I went to find Sonny Ray.

I looked all over the place—at his corner, behind the cafe, all through the parking lot. Finally I peeked over a stack of used tires behind the garage. The black tires were warm and there he was, squatting inside. I said, "Well you aren't doing much and it's a nice day so let's go and bury Pits."

When we got there, poor old Pits looked pretty much the same. His head was tilted a little more and I got afraid it'd fall off when we cut the wire around his neck but it didn't.

We scraped a hole in the dirt but not very deep because we didn't have a shovel. I used a stick and Sonny Ray used a baby food jar he picked out of the freeway trash but it wasn't much good being glass and so small but we got a grave scooped out and put Pits in it. I remembered his feet before we covered him up and had to look for one of them and I found it under an empty Coors carton.

I didn't want to give up the Medal of Honor, but really, it didn't belong to me. I lifted up Pits's coat and dropped it through his ribcage. Then we covered him up and Sonny Ray said a prayer and I asked Jesus to tell Pits that everything had been taken care of and goodbye.

On the way back Sonny Ray was pretty quiet. Maybe burying Pits got to him, but I doubt it. He didn't know him that well so I asked him what was wrong.

"I been thinking about this awhile. I'm old and tired and cold most of the time and who gives a rat's ass?"

"I do."

"Yeah, yeah."

And then we didn't talk any more, but I wasn't going to let that ruin the party tonight, except, Skipper might be there and I didn't feel like trying to talk him out of killing himself.

Come night, me and a few friends found some broken pallets behind the garage. We tied the pieces together with an old yellow extension cord I found in the dumpster and pretended we were sled dogs dragging our load through the snow. I'd say, "Mush, mush." And sometimes, "Oatmeal, oatmeal," and everybody'd laugh. We dragged them down into the sandy wash behind the truckstop between my place and the lowlife camp. It's wide and the brushy banks are far enough away that we can have a good fire.

Pretty soon we had one going and everybody talked a lot and had a good time and some were drinking but not me. A long time ago when I was a teenager, I went to a boonie party and drank a lot of salty dogs. Later we went to a drive-in to get something to eat and when the carhop came to take our order, I opened the back door and sort of fell out and puked all over her feet. Her squeaky little scream stuck in my head forever. She called me disgusting and I was.

Anyways, we sat around the fire and told funny stories and laughed. I told my Mississippi riddle. "Can anybody spell Mississippi with one I?" They all shook their heads and Marcy tried to leave out all the i's, but then they all gave up. I covered one eye with my hand and spelled Mississippi. Marcy called me a little shithead. Of course she smiled when she said it.

Then Skipper stood up and opened his big mouth. Lies are okay if they're pretend, but Skipper believed himself. He couldn't have had that many women and done the things he said, but maybe he used to look better. He set his captain's hat with the filthy gold braid straight. The loose skin under his neck jiggled as he puffed himself up and leered at Marcy. She has a real job, selling newspapers on the corner and does pretty good, being a lady and all. She isn't bad to look at either, even if her face is sunburned and peeling.

She lifted her arms and fluffed her short, curly hair and when she did that, I could almost see between the buttons of

her stretched-tight blouse. The skin around her brown eyes crinkled and she smiled at me. "Jacko, you keep your eyes off my bosom." And I did. You have to be somebody before Marcy'd mess around with you and nobody here was.

Skipper licked his lips and pinched the rooster skin hanging off his neck and said, "I'm too big for most women. Much too big. They can't handle it." Then he stared full at Marcy. "Do you think you can handle it?"

We all went quiet waiting to see if Marcy was going to deck him. She threw a rock into the fire and sparks flew up into the night. A party isn't any fun if there's fights, so to take Skipper's mind off Marcy I dropped a cigar butt I picked out of the dirt into his bottle of Mad Dog 20-20.

He took a sip to wet his throat and looked at Marcy and said, "About ten inches, can you handle it?" The butt must've sunk. Marcy jumped up and yelled in his face, "I don't like talk like that," just as he took a bigger swig of wine. He got the butt that time and folded forward spitting and gagging. Marcy must've thought he was laughing. She called him a creep and pushed him towards the fire. He staggered and tottered just like a drunk in an old black-and-white comedy.

Well if he'd burnt up it would've really ruined the party so I grabbed him by the sleeve and pulled him back before he fell face first but the bottom of his long baggy coat caught on fire. I skinned it off and somebody poured beer on it and it sizzled out.

Skipper flopped around for a minute or two then rolled over onto his hands and knees. He crawled around moaning, "I swallowed a cockroach, I swallowed a cockroach." Like an old blind dog going in a circle, he would've crawled back into the fire but I held on to the back of his shirt and led him away. He crumpled over and sat with his arms hanging limp and said again in a surprised voice, "I swallowed a cockroach, how could that happen? There are never roaches in my house, never. I make my wife keep the house and the girls spotless. See, see." He handed me a picture so creased and faded, I couldn't see anything. Then he cried.

I never knew he had a house, much less a family. He smeared his face with the back of his hand and said through his sobs, "Thank you Jacko, you saved my life, my life that is."

Marcy stood with her hands on her hips staring at me hard. "Why'd you bother to save a creep? He ain't no good to no one." Then she went and sat on the other side of the fire.

Now I'm a thinking man, and that made sense. Skipper was a creep and nobody liked him, so why bother? I guess I saved him because I'm the one who put the cigar butt in his bottle. Anyways, the party fell apart so I said goodnight and went home.

Skipper must've sat on the cold ground up against my part of the house most of the night. When I crawled out next morning, he pulled himself to his feet, inch by inch, up the side of the tree I hang my stuff in and offered me a drink out of a bottle in a brown paper bag and said don't worry it's a fresh one. Since he never offered anybody anything, I guess he was trying to be nice. I shook my head so he took a drink and put the cap back on.

He told me I was his only friend and nobody else liked him, and he didn't have anything to live for. Well the last two parts were right, but that's something you can't tell people.

I heard somewheres that some people believe if you save a person's life, that life is yours. I didn't want Skipper's life any more than he did, but I tried to listen, except his coat smelled like a wet-down garbage fire. I said let's take a walk. It's easier to talk to somebody you don't like when you're walking. You can look where you're going instead of at them and not hurt their feelings.

We walked through the desert a long ways, me kicking dirt, Skipper mumbling and flapping open his coat. The ends caught on prickly pear cactus and were full of thin stickery thorns but he didn't seem to notice. We finally made it to the road that goes to the sewer place. It's a long straight paved road that only the sewer people use to go back and forth to work. You can see somebody coming for a long ways. It was easy walking on the pavement, until we got up on the overpass high above the railroad tracks. Skipper'd been drinking all the way and barely

made it to the top. He flopped down against the guardrail and I sat down beside him.

For a little while he leaned back with his eyes closed getting his breath back and I almost felt sorry for him again. Then he handed me a crumpled up paper bag and said, "Do something with this for me, would you please."

Well I thought it was the bag off his bottle and he meant find a place to throw it so I stuck it in my pocket. "Jacko, I'm no good to anybody, you're my only friend."

I wished he'd think of something different to talk about. "Oh man, don't keep talking like that," I said. "Look. Look," and I pointed into the sky, "There's a hawk. I bet it's a mother. I bet she's looking for a rat for her babies. She can see a rat, a mouse even, from way high in the sky."

But he didn't look at the hawk, he looked at something festering in his head. "My little girls, you know my girls, I never hurt them, I swear to God I only loved them."

"That's okay," I said, "everybody feels like hitting their kids and sometimes they do. Even critters get mad at their babies."

Except, Skipper wasn't talking about spanking his kids because he put his hand down there on himself. Then I knew what he'd done to his girls. Maybe. Maybe he just would've liked to.

If I look straight up and not see anything on the ground, I can swim away in the cool blue sky. I swam away from Skipper's voice until it was just a tiny fly buzz in my ear. The hawk and I circled and glided and I wanted to keep going until the sky became dark blue like it is when you're in a rocket ship, and there weren't any clouds, but something didn't feel right. Skipper was moving around kind of quiet like so I blinked a few times and came down out of the sky.

And when I looked up at him he had put a loop of yellow extension cord around his neck. All I could think to say was, "Hey, hey."

He'd tied the other end to the guardrail post. And, oh man, he stepped over the rail into the air, only he didn't swim away, he dropped. It took me a second to believe he did it. When I

looked over the guardrail, it seemed he should be standing on the railroad tracks below looking up and waving, only he wasn't. He jerked and danced and clawed at the cord around his neck, then swung slow and lazy back and forth.

The long blade was busted off my red knife and I tried to cut the cord with the bitty short one and couldn't. The knot on the post was pulled so tight I couldn't get it undone and then the cord stretched and snapped.

He fell onto the tracks and lay as still as a pile of dirty rags. I got down pretty fast. A little bit of blood smeared the tracks but not much because he was dead when he hit. He looked like he was taking a nap and not much worse than before, only his neck was popped crooked. I tried to feel sad but all I felt was relief that I didn't have to pretend I cared any more.

The wine bottle had busted beside him and sogged the bag red and I remembered the bag he handed me. I dumped out eight dollars and eighteen cents, the folded up picture and a scribbly note on a torn piece of paper that said, "I love you Dina and Nan, I love you." Well, I guess Dina and Nan were his little girls, except they'd be grown by now because Skipper was about sixty. Maybe he wanted them to have all his money. That'd be four dollars and nine cents apiece. I decided I'd keep it for all the hassle he'd caused me.

The slip knot came off his neck easy only it left a deep groove. I went back up on the overpass, and since Skipper wasn't hanging on the other end, the cord untied from the post okay. On the way back to the truckstop I tossed it into a big prickly pear cactus. In case what family he had ever found out he died they'd never know he hung himself, especially after a train ran over him.

Nobody ever did ask where Skipper went except Marcy. She said she hoped the creep had been run over by a semi and was rotting in hell. I didn't tell her what really happened. She has a job and knows people who live in real houses. What if she told somebody, I could get in trouble.

I really needed to get back to the cemetery and see if Mrs. Wilkers was still there and check on my grandma's house but

first I had to go to Slammers. To compete in the Beautiful, Bountiful Babe contest the ladies have to weigh over two hundred fifty pounds.

XII: Jacko

MY SIS TOLD THE BARTENDER NOT TO let me sit in front and watch. She said some drunk Mexican truck driver with a knife might pick a fight and then what would I do? He could cut me into teeny little pieces before I could say Jack Robinson.

She doesn't know what she's talking about. A gringo with a knife is just as bad. I get along with Mexicans just fine. I smile at all of them because you never know who's related to who. Anyways, I'm a man and can look after myself.

Truckers and Mexicans hang out at Slammers and like big ladies and I like to look at them too, there's so much more to look at. So I lay under the bushes by the back door and watched them go in.

Their bright-colored clothes shone under the porch light and every lady looked different—one like a large, shiny, fairy godmother and one like a queen-size peach, plump and ripe. They all had on silky stockings and looking at their legs made my mouth water just like it does when I look at the fat, juicy sausages in the truckstop deli.

The last lady had long, blond, wavy hair hanging down her bare back like a silvery waterfall.

I must've breathed too hard and rattled the leaves. She

stopped and turned sharp, her hair swirling over her face, her head cocked, listening. "Who's there?"

Well I sure wasn't going to say it was me so she said again, "Who's there in the bushes? You better answer or I'm gonna kick some goddamn ass."

The ground shook as she stomped over. She seemed familiar and it was on the tip of my brain but there wasn't any time to think about it because she had me by the arm dragging me out and yelling. "You fucking pervert, come out from under there."

She stood me up in front of her like I was a puppet and raised her fist and, oh man, I knew who it was because this all happened once before. "Hi Darla, it's me, Jacko. You sure look pretty."

"Sweet thing," she said in a shivery, squeaky voice and grabbed me to her bosom where the gold sequins scratched my ears and it smelled like cinnamon apples. Darla must be over six feet tall in high heels and my toes barely touched the ground. She kissed both my eyes before she let me go. "I'm not mad anymore sweety, how you been?"

"Okay I guess, you still trucking with Arnie?"

"If you mean Alabama Chicken Choker, shit no. His wife's riding with him now. I went to Vegas. It sucked. Too much competition. Now I'm back. You know Rosario, long black ponytail and wears a gold crucifix?"

She really wasn't asking, but I know him. He works the truckstops dealing marijuana. He's one of Salazar's cousins and I pretend like I don't know. Rosario doesn't let it get in the way. I guess Salazar doesn't either.

"I'm kinda hanging out with him. I gotta win this pageant. Five hundred dollars first prize. Oh my little sweet thing, I'm glad to see you, you're the only one who doesn't want something from me. Come on in and watch."

"My sis told the bartender I couldn't."

"They don't give a shit and your sister ain't here. Go around front, I'll tell somebody it's okay."

So I did and *El Musculo* let me in and that's what he is, one

solid muscle. He works the front door and lives in a trailer be-
hind the bar. "Hey dude, what's happening? Don't worry, I'm
not going to rat you to your sister, she'd probably knock hell out
of me."

He must've been kidding, he's taller than Darla and my sis
is little like me. "So Jackito, who's your new girlfriend?"

It was too noisy to explain anything—so I just said she was
only a buddy. He got a chair, put it in the corner and told the
barmaid to bring me a soda, a real one in a can and not a puny
glass full of ice and a spoonful of Pepsi.

The truckers laughed and smoked and drank beer. Pretty
soon the announcer came out on the plywood stage. Then it got
really noisy, stomping and whistling and pounding on the ta-
bles. He held up his hands and it took a minute to get quiet. He
told about the first lady and hopped off the stage.

The four-piece cowboy band did a crash, bing, bang thing
and a black lady came out of the owner's office and the an-
nouncer helped her up the step.

She had beads and bones braided into her hair and carried a
spear. It looked like it took four zebras to make her bathing suit.
The band played some tom-tom music and she moved like a
landslide and one of the guitar players had to jump off the stage
because there wasn't enough room for all of her.

Everybody laughed and clapped and stomped some more.
My head filled up with cigarette smoke and bar floor dust and
the Pepsi tasted like beer. I had to get out.

The Muscle asked was I okay. I nodded and got outside and
felt better. I should've known it wouldn't work—me inside with
a bunch of people, breathing their used up air. I thought about
going home, but then I figured I'd wait for Darla.

When the Muscle came out like he does every now and
then to see if there's fights in the parking lot, I told him to tell
Darla I'd be where she found me before.

Except for Muscle's rusted out Blazer, the parking lot was
empty when Darla reached under the bushes and poked me
with her shoe and said, "Wake up damn it." Then she poked me
again.

"What is it? What's wrong? Oh man Darla, you didn't win did you?"

"Come out. I can't talk to you all bent over like this."

So I crawled out and sat on the step under the porch light. She took a towel out of her bag and wiped her face and smeared her makeup.

"You'll get your towel dirty on that step."

"Who cares, it's a Motel Six freebie."

So she spread it out on the concrete and sat down next to me. "Why did Motel Six give you a towel?"

"Oh shut up Jacko."

The light shone on her magic dress and each golden sequin seemed alive. She crossed her hands on her knees and lay down her head. A winter moth got trapped in her tangled hair and she didn't feel me take it out and let it go. She shivered hard and I took off one of my coats and draped it over her shoulders.

Darla raised up and looked into the dark. "No, I didn't win. The jungle bunny did. I really needed that five hundred bucks."

She cried soft-like and I wanted to say the right thing but I couldn't think of it. "Has it got to do with Rosario? Is he your boyfriend? Did you break up with him?"

"We were never together—except horizontally. And yeah, it's got a lot to do with Rosario."

She got a roll of toilet paper out of her bag, pulled off a long piece and blew her nose hard. "I always carry toilet paper. I never know where I'm going to be. Just like a girl scout, always fucking prepared."

Darla rolled the toilet paper into a little ball and threw it in the weeds. "I owe him four hundred bucks. This is Friday, well Saturday morning. I'm supposed to meet him Sunday and I don't have it."

Inside the bar, a Mexican song about somebody's broken heart played. I know the word for heart. Corazón.

"Rosario fronted me four ounces of smoke. Me, big time drug dealer, was going to turn it for a hundred and forty a Z and make a lousy one hundred and sixty on the deal. Damn, damn. Mexicans have names like Angel and Jesus, only they ain't.

They all carry knives and'll kill you if you insult their mother and I owe him money. What's he gonna do to me?"

I didn't know. He could cut her into teeny little pieces before she could say Jack Robinson. "What'd you do with it, the marijuana?"

"Smoked it, toked it, stroked it, how the hell am I supposed to remember that? I did sell two hundred worth to buy this dress."

She smoothed dimpled hands over her giant golden delicious apples and the sequins crackled and the fringe around the bottom of her mini skirt trembled. "It's the prettiest dress I've ever owned."

Darla said I was the only person who never wanted anything from her, but that's wrong. I wanted her to grab me to her bosom again, hold me on my tiptoes and kiss my eyes. I wanted it so bad my stomach squeezed into a tight, twangy knot and my teeth clenched so tight I couldn't move my jaw to talk.

She stood up and my coat fell off her shoulders. She shook the towel and crammed it back into her bag. "Still don't talk much, do you? I gotta go sweety, I'm staying with Muscle tonight. He's waiting for me in the bar."

He must've been listening, the door opened before she touched it. She patted my cheek and went in. I picked up my coat and put it on.

I thought about Darla's trouble while I crossed the freeway back to the truckstop. I couldn't give her the money or fight off Rosario. He wouldn't listen to me about how nice she is either. Nobody listens to me except Salazar.

Cops don't give anybody their phone numbers, but because my sis lives with him, I have his. The middle of the night is a good time to call people because they're always home. He cussed when he heard Rosario's name and wouldn't let me explain on the phone, said to stay put and he'd be there in a little bit.

He pulled up close to the phones. I got in his pickup and he rolled down the window, popped a kitchen match with his thumbnail and lit a cigarette. My sis made him shave his mustache off because she said it smelled like an ashtray.

We drove east on the freeway while I told him about Darla and how afraid she was of Rosario's knife.

"Rosario doesn't carry a knife, he carries a .45, cocked and locked. He's not going to cut her, the deal's not worth it. But he's not going to let it go either. She owes him."

"Please Salazar, I'll visit my sis for two whole days and do whatever she says if you'll do something."

He hardly ever smiles, but he laughed out loud. "Means that much to you, does it? Okay, I'll take care of it. That's what Rosario gets for thinking with his dick. Where is she?"

I told him and he turned around through the median and we went back to the truckstop. He dropped me off behind the last row of trucks.

There wasn't much night left when I got back to my place so I didn't bother to lay down. I couldn't have slept anyways wondering about Darla.

A flattened roll of carpet bent into an L and leaned against a small tree makes a good chair. I got comfortable and waited for the sun to creep over the faraway mountains. That's the best time, before all the energy leaks out of the day.

When the sun rose high enough to warm my face, I drowsed off. Half asleep and half awake, looking through my eyelashes, I saw myself with a long black ponytail and a gold crucifix gleaming on my chest and a .45 cocked and locked in a black leather holster worn in the small of my back and everybody listened to me. But I couldn't make my pale eyes and faded eyebrows fit into Rosario's brown face.

It was chilly sitting there so I turned to crawl into my house to take a nap but I saw somebody coming down the path. Darla, and she hadn't been cut up, and oh I was glad, but now I had to spend two days with my sis. I jumped up, but Darla wasn't happy to see me as before. I didn't get hugged.

Her hair was mashed flat on one side. She had on a yellow sweatshirt with Slammers across the front in red and a pair of gray sweatpants and dirty white sneakers and no socks. We sat on the roll of carpet. She put her bag on the ground by her feet.

I didn't have to ask what happened, she started talking as

soon as she shifted around and mashed in a comfortable spot. "Rosario showed up at Muscle's last night."

"But...."

"Just listen, okay? Me and Muscle just finished fooling around again and I was laying there thinking about getting up and going to the bathroom when there's this banging on the front door. Muscle dragged the bedspread off and wrapped it around himself and went into the living room. I heard the door open and somebody came in. I didn't pay much attention because they were talking Spanish."

"Didn't you recognize Rosario's voice?"

"No. He always spoke English around me. Don't interrupt okay? The bedroom light went on and Rosario was standing in the doorway with the biggest knife I ever saw and Musclehead was hovering behind him not doing a thing. I about shit myself. But you know—"

"Know what, know what?"

"I said don't interrupt."

"But you quit talking."

"Because I didn't think of it till just now. It looked like a kitchen knife and it really wasn't that big. Why would he be carrying a kitchen knife for Christ's sake, to dice up pinto beans? Mexicans carry switchblades.

"That bastard. He went through my bag and took out my dress. Rosario held it to his cheek and took a deep breath. Then he stuck that—that vegetable knife right in the middle and cut it in two. He shook his head like it was such a shame, and you'll never believe what he said, you'll just never believe it."

I was afraid to say anything, she kept getting louder and louder. I shrugged my shoulders.

"Well, don't you want to know?"

While I was trying to figure out what to say that wouldn't make her madder, she forgot she asked me.

"Rosario, that beaner, said, 'That's what I get for messing around with fat girls.' Look, the most beautiful dress in the world."

She yanked it out and shook it and a zillion sequins

scattered, blinking in the dirt. "That goddamned jerk didn't even have the decency to wait until Sunday like he said he would."

"Oh Darla, I'm sorry. I wish—"

"I'm getting a ride out of this shithole as soon as I find a truck going back to Vegas. You got any money?"

I gave her all I had. Six dollars and twenty-two cents. She put it and her torn-apart dress back in the bag and reached for me with both arms and surrounded me with herself. "Thanks darlin', I'll see you around."

After she left, I picked up the sequins, every one. I stirred a stick through the dirt so's not to miss any. I felt so tired, I lay down on my side on the ground and held a handful to my lips. They smelled of apples.

XIII: Marie

SALAZAR'S PROPERTY BACKS AGAINST state land and there's an unobstructed view to the eastern mountains. They are young, pointed and craggy, not worn smooth by the particles of time. It's a pity people age the opposite of mountains.

I sit on the back step in the early morning sunshine. A faint warmth stains the air and I feel free—laundry done yesterday and the house cleaned the day before. Sometimes when I'm free, I'll read the day away—I'm on Orwell now for the third time. I suppose I could find a domestic chore that needs doing, such as cleaning the oven to keep me out of trouble. Still, dirt like the poor is always with us and I need to get out of Dodge.

I soak up more rays and consider. Salazar and I target shoot on the small, low hill covered in brush and prickly pear cactus about a half mile straight ahead. I step inside, open the closet, take my gunbelt off the hook and strap it on. The bluing is worn on the barrel and cylinder of the .357 magnum from in and out of the holster so many times. It is heavy and comforting, a Smith and Wesson Highway Patrolman with a six-inch barrel. I open the cylinder and push out the hollow points and put them in my pocket. They're too expensive to shoot at targets. I load up again with six reloads and put the rest of the box, forty-four

rounds, in a day pack with a water bottle, paper target, roll of masking tape, and ear plugs and head for the hill. I have a fleeting thought about taking granola bars but, by golly, I think I can last that long without food, so I don't.

The sheet of plywood has fallen over and I prop it up with dirt and rocks. It is full of holes and splintery. We'll have to drag another sheet over soon. We've placed it where it won't hit any of the saguaros or larger growth. Johnny had a fit one day when he saw a bullet hole in a tree.

When Salazar and I shoot, he brings a staple gun to fix the target to the plywood. I didn't feel like carrying it, it's heavy. I figured the masking tape I use for the blast holes would work. It doesn't stick very well to the rough plywood but will hold the target fast for only fifty rounds.

There are animal silhouette targets available. I'll never shoot an animal. My target, a human shape, black silhouette on a yellow background is numbered in concentric, vertical ovals starting from number ten in the heart area, to lesser numbers radiating outward. The ten ring, or kill ring, is where you want your pattern.

I walk about twenty feet back and put in the ear plugs. The trigger pull is stiff and, one-handed, I waver. Not good. Double-action shooting is difficult to master and hard to maintain. Salazar says I should have a semi-auto, a .45. However, if I must have a revolver, maybe a .38 special with a two-inch barrel so I'll have more control. Like hell. The old gray mare ain't what she used to be but she can still kick dick.

Two-handed, I aim each shot and slowly empty the pistol. Back at the target, it isn't Annie Oakley time. Three are off the board, one a neck shot and two on the line between the nine and ten ring. I tear little pieces of tape off the roll and cover over the holes so I can eliminate them from the new.

Most gunfights happen within a range of six to ten feet and there isn't time to aim; instinct takes over. I step closer, reload and fire rapidly. The pattern is all over the place. Good thing the target can't shoot back. I don't practice enough, but then I'll probably never be in a gunfight.

The holes retaped, I take a deep breath, let it out slowly and, muy rapido, fire again. I repeat the process until I'm down to my last six rounds and it's four in the ten ring, one in the nine and one in the seven up high. I reload with the hollow points from my pocket and snap the .357 back in the holster.

A yank brings down the target, and folded, it goes into the day pack to throw away later. The brass lies scattered and it takes a minute to pick up each spent cartridge and, before they all go into a zippered side pocket, shake out the sand.

On the way back, I count five different species of wildflowers coming into bloom. Someday I'll look up the names. Overhead, vultures glide. The first so far, up from Mexico. They'll be here now until the middle of October. It's been a wet winter. That means lots of undergrowth, lots of little critters, lots of road kills. It'll be a good year for vultures.

I don't want to go into the house because there's always something to do. Salazar's yard jeans need patching and the grubby oven beckons, so I sling my gunbelt and pack on the seat of my car, get in and figure I'll drive around and maybe see what Johnny's up to.

Behind the cafe where the trucks park is like a bustling Old West town, except there's no horses. Drivers walk to and fro, coming and going to the cafe and showers, maybe visiting with other drivers. A three truck line waits at the truck wash and all the spaces at the oil change racks are full. As I drive slowly along the front row of trucks a couple of truckers up high in their cabs give me a long look and I think, oh boy, I can still turn heads. Then I realize it's probably the gunbelt on the seat they're staring at.

All through the truckstop, no Johnny. He could be anywhere though, especially if he saw me, or at the cemetery. Now that I'm here, I'll walk on back to his place. But what the hell am I going to do with my pistol? I can't leave it in the car. Somebody might see me lock it in the trunk and it would only take a sturdy screwdriver to pry it open. Rats.

I park out of the way and strap on my armament. In Arizona, it's legal to carry a handgun if it's not concealed and legal to

THE YELLOW RIBBON SNAKE

carry concealed with a permit. This hunk of steel is not a
cheesy Saturday night special I can hide in my garter belt. For-
tunately, my jacket is long enough to cover up the works.

Now, protected by the shield of arrogance that packing a
six-gun generates, I am impervious to the fear of being attacked
out in the bushes. Why didn't I carry before? Johnny doesn't
like guns because he connects them with hunting. The wind
gusts and lashes the brush on either side of the well-trodden
path. I walk tall, the big iron heavy on my hip. The feeling of
power enhances my senses. No longer am I a dime-a-dozen
middle aged woman grubbing around in the bushes looking for
her birdseed brother. I am Gary Cooper and it's high noon. My
hawk eyes narrow, watching for the imaginary bad guy to saun-
ter out of the saloon and into the middle of the dusty street.
And, oh shit, one does.

A lowlife from up the wash steps out of the brush in front of
me. He is so covered in grime that his clothes and body blend
together into a walking dirt clod. Johnny and Sonny Ray's place
is directly ahead and that's where he's going.

He doesn't see me, or it doesn't register in his silt encrusted
brain that there's someone else on the path behind him. He
walks with a hitch, so I slow down and follow along. Johnny
and Sonny Ray hide all their good stuff, but by their box, I mean
house, a jacket hangs in a tree and a wooden chair without a
back is placed under it where Johnny sits of an evening and
watches the greasewoods grow.

Crudclod picks up the chair and reaches for the coat. I say,
"Put down the chair and leave the jacket alone."

He drops the chair and whirls around. "You don't live here.
Who're you?"

"Adelita."

"Never heard of you." He pats and fumbles in his clothes,
the carcinogenic aroma of a bushel full of rotten onions fills my
lungs. He's looking for a knife. I step back far enough where he
can't cut me if he lunges. Most lowlifes don't have guns because
if they ever run across one it represents so much cash that they
sell it immediately. Living out though, they all have knives.

Finally he pulls it out of his rags, a clasp knife, and opens it on the second try. It has a wide, wicked, at least four-inch blade.

The lowlife shuffles forward a step, his eyes on mine, the knife held low, thumb on top, the proper way like you hold a flashlight. He's done this before, but a long time ago when he was younger and cleaner. He's shaking and I don't think it's from fear or excitement. He needs a drink or has a disease, probably both.

I could tuck my tail and run, it'd be easy to outrun him, but I'll be damned if I will, and to back up anymore will only bring him forward. He most likely knows Johnny and Sonny Ray's comings and goings. He wouldn't have the energy or courage to confront them, and why anyways? He can sneak around while they're gone and pluck their treasures at leisure, but I'm only a woman and, he thinks, easily intimidated. That thought pisses me off.

My coat makes an impressive whooshing sound as I whip it open. I pull the tail back and tuck it behind the butt of the .357. Dirty Harry rules. I say, "You see this dickpuke? This is maybe the second most powerful handgun in the world. If I draw it that means I'm going to blow you a new asshole." Then of all the times I've watched that darn movie, one of my most favorite lines ever flies right out of my head and I say, "Go ahead and have a nice day."

The top part of his body leans forward, his feet don't move. It's like he can't believe what he sees. My holster has a quick release thumb snap and I pop it open, hand around the grip, index finger extended on the outside of the holster in position to pull the trigger if I have to draw.

The sound of the snap perks his attention. He freezes except for the skin that twitches around his bloodshot eyes. The irises are the color of dry concrete. His defined cheek bones go with a high bridged nose. The rest of his face is covered with greasy blond fur. He must've been handsome and I wonder at what point in his life he chose to become a troglodyte.

We stare at each other. A shitload of grievances radiates out of my eyeballs into his and he knows I'm not afraid. The knife

wavers and he drops his arm to his side. "You can't shoot me."

"Yes I can—it's quite easy."

Both arms at his side now, he stamps his foot, "But it's not fair, you have a gun and I only have a knife."

Well, that kind of makes sense so I say, "Oh do be gone. If I ever see or hear of you back again, I'll bring somebody mean enough to take that knife and carve out your heart."

I could demand he hand over his knife. That would start an argument and really piss him off—it's probably the only good thing he owns. Then I'd have to kill him or run and I don't want to do either. Besides, he'd only get another. His shoulders droop and he hitches off into the brush. I watch him out of sight and his stink lingers on the back of my tongue.

This is what drives me nuts, thinking of Johnny living in this kind of world. I'd have had to turn tail and run if I hadn't had my pistol. Then ole dirtbag would have won and gleefully shuffled off to Buffalo with all he could carry.

I collapse on Johnny's backless chair and resnap my holster. Being a macho bitch kind of takes it out of you. Johnny and Sonny Ray keep it swept around their house so they can see not to step on a snake. Some pretty big rattlers live in the rocks on the other side of the wash. There's no trash around and they don't shit in the bushes close by—keeps the mice away. The way they have small stones lining the last bit of path to their house under a mesquite tree and everything so neat, reminds me of the Three Bears' cottage in the woods.

By and by, I hear somebody coming up the path. I stand and flip aside my coat, tense and surprised that the lowlife is stupid enough to come back. He walks around a big greasewood bush whistling a tuneless tune under his breath. It's Sonny Ray carrying a grocery bag in each hand.

"Hey, hello Marie, there ain't a bounty on my head, least-ways not that I remember." He swings the two bags under the rubber mudflap door into his house and says, "Like a cup of joe? I can have one fired up in a minute and then you can tell me who you're gunnin' for."

"That'll work."

His face, like a small woodland creature drawn by Garth Williams, is gentle and entreating and I marvel that he and Johnny manage as well as they do. He makes a fire of pages torn from Time magazine and twigs in a small circle of rocks and when it catches good, places a rusty grate over the flames. He asks to use the chair and I move. He adjusts it minutely, climbs up, reaches into the tree and unhooks a bag made of, it looks like, pant legs off a pair of camouflage fatigues. Things clink and rattle and out comes a blue enamel coffee pot that he fills about three fourths full of water and puts on the fire. The water comes to a boil and, out of the same bag, he pulls a can of coffee and throws a handful into the simmering water. It bubbles up and he uses his bandanna as a hot pad and removes the pot from the fire. "Gotta let 'er sit and settle."

After a bit, he carefully pours two mugs full. "Now, you know not to drain your cup 'cause of the dregs?"

I nod and blow over the top to cool it enough for a sip. "Good, Sonny Ray, this is good." Cowboy coffee. They make it like this at Indian rodeos. It tastes like horses and cows and coiled nylon rope, laughter and the creak of oiled saddles.

He's pleased to be a host and sits on a stack of four wooden pallets. I tell him why I'm carrying and about the lowlife. He sets aside his coffee, stands up, paces back and forth, then sits down again. "I know," he said, "and it's getting worse. There's twice as many lowlifes than last year. Too many people, just too many people—everywhere." He sighs and sips his coffee. "Too bad the lowlifes can't be exterminated like the cockroaches they are."

He looks at the ground and taps his heel against the pallet. "I'm thinking of going to my family in Kansas. They said I could take care of the poultry. There's no place for me to stay right now, but they're gonna set me up a little camp trailer and park 'er by the woodshed. Winters are colder than here. I'd be inside though with a 'lectric heater to keep me warm."

My heart sinks down into the toe of my boot. I burst out, "What will Johnny do without you?"

"Don't know, I got to save myself. Seems like the time

between forty and sixty-five has been some kinda dream it's gettin' harder and harder to remember. Where'd it all go, all those hours and minutes and seconds? And here I sit now, worried about a lowlife stealing my coffee pot. It ain't much fun anymore doing my own thing."

The grounds at the bottom of my cup form into nothing much at all. I swirl it and they settle into nothing much again. "Good coffee, thanks. When do you plan on leaving?"

"Any old time, now it's gettin' warmer."

Warmer, yes I guess it is. "Then this might be the last time I see you?"

"Might be. So I gotta say something, though it ain't none of my business. I know you know this but I gotta say it anyways. Jacko's looked for his mother all these years only with his mind. He lives in his head, and so, still lives in his gran's house. When it's gone, he'll be homeless. So you need to watch that."

"We've tried, Salazar and me."

"Yeah I know, Jacko's always dodging you. It's kind of a game. Maybe if you left him alone it wouldn't be fun anymore."

"I can't do that."

"Yeah, I know that too." Sonny Ray takes his ball cap off and rubs his head, "Smile, you look young when you smile."

I wave my hand, dismissing his comment, shake my head and smile. "You're only as young as you feel, right?"

"Nope, you're only as young as you look. Smile now, and when Salazar is fifty, he'll look like your father."

My nose starts to run, the predecessor to tears. I stand and place my cup on the chair. I step over and hug him. "All the chickens and ducks will love you. You've been a good friend to Johnny." I wipe my nose on my sleeve. "Don't forget to send us a postcard from the wilds of Kansas."

"Not to worry. Remember now, smile."

My grin feels like the rictus of a thousand-year-old mummy. I turn and leave before I bust into tears. Old Sonny Ray, haunted by approaching decrepitude, trying to save himself and all I feel is pity for poor old Marie. Your youth was a paper target, a silhouette fired at in slow motion. A painful hole blasted one

year at a time and you taped it over and taped it over some more and everything was pretty okay until you started running out of tape. You just need to carry an extra roll. Now, dry your tears, go home, don rubber gloves and clean your fucking oven.

XIV: Jacko

I ROSE FROM THE DIRT AND PUT Darla's sequins in a bread wrapper and tied a knot in it. I mooshed them around while I walked to the cemetery. Salazar said I hang out there too much and I might go crazier talking to dead people. Except, a lot of people are easier to talk to now that they're dead.

It's only a mile or two to the cemetery but I was kind of tired when I got there so I lay flat on top of the wall and looked at the sky. The white clouds churning around in the blue sky reminded me of my grandma's old wringer washing machine. She'd fill it with the hose and put in the laundry bluing, then plug it in. As the blue water agitated, I put in the soap powder and when the white froth formed, I'd poke the clothes into the water with a long piece of shovel handle.

After I rested, I hopped down inside and went and leaned on Jesus the Good Shepherd and wondered, like always, what kind of person would break off all His fingers. I touched each stub and looked into His chipped face, then took a twig and scraped the bird poop off His cheeks and shoulders while I thought about how Jesus never did have an easy life.

Then a station wagon pulled up in front of old Mrs. Wilkers's place, and her boy Donnie got out. Donnie and me used to

be friends. Donnie's dad worked for the cemetery, he was in charge of the oven. Their house is closest to the west gate, so the concrete coffin covers were stored in their yard. Me and Donnie would jump up on them and play King of the Mountain.

Mr. Wilkers's name was Gary and he'd laugh when you'd call him G. Willikers. Mrs. Wilkers found him crushed dead under a concrete coffin cover one morning. The cops figured he'd winched it up to inspect for cracks and the winch failed. The cemetery people gave him a free space to be buried in and let Mrs. Wilkers stay on. I bet they didn't think she'd live as long as she has. She wore a pink dress to his funeral. She was my grandma's best friend. Mother left pretty soon after he died. Mrs. Wilkers sent Donnie away and I haven't seen him until now.

I visit her every once in awhile, but she won't talk about Mother. She only says what a saint my grandma was, but I already know that.

Anyways, Donnie got out of the station wagon and went to the door. I hadn't seen him in over thirty years but he's the sort of person who doesn't change much. Same round face only redder, same mouse brown hair only less, same chubby body only now dressed in a light gray suit and a dark blue tie instead of the new dress pants he used to play in. He never wore jeans. My grandma said Mr. Wilkers burned or buried all the corpses naked because he'd take off their clothes for his family to wear. I climbed over the wall and went across the road to say hi.

He didn't know me at first. "Jacko, you mean—Johnny that used to live there?" And he pointed to my grandma's house.

"Yes that's me, Jacko that used to be Johnny."

Donnie pumped my arm while he patted me on the shoulder. "Well hell, Johnny, you haven't changed a bit. Same scrawny runt as ever. I envy you your figure." He let go of my hand and slapped his belly. "Yes sir, I've added a few. So how you been?"

"Okay, I've been okay. How come I never saw you around?"

Donnie twined his fingers together and looked at his palms. He flipped his thumbs and turned to Grandma's house, then to

his mother's house, then to me. "Well Johnny, things change and I don't live very close. I came and picked up Mom a few times—I must've missed you. Mostly she'd take a bus to my house. Look around. This whole scenario's major depressing. I'm only here because Mom won't leave on her own and besides she's past it. Christ, who'd want to come here? Poky little houses filled with old people just waiting to die." Then he whispered and rolled his eyes towards his mom's house, "She hasn't been right for a long time."

So I looked around and the boarded-up houses did seem smaller. The scraggley dried-out yards withered in the pale sun and even Mrs. Wilkers's house had a feel of dejection. A gritty cold wind blew down the cracked and pitted street and it seemed like an ancient place. Like Egypt maybe, with the sand blowing around all those hollow tombs, and all those lonely kings and queens lying there who used to be beautiful and ride in chariots and now they've been husks for thousands of years and I didn't want to think about that anymore.

Donnie put his hand on my elbow and kind of herded me into his mom's house. Everything was the same as when we were kids, except for the big new TV set in the corner of the living room. It all had the look of a faded color photograph.

Donnie stepped into the small room and before he said anything, picked up a picture in a silver frame and looked at it a minute. "Me and Mom and Dad. I was happy before she sent me to live with Aunt Rose." He turned to me and quietly said, "We had some good times, didn't we pal?"

I couldn't remember that we did have very many good times, but I nodded, "Sure thing."

Mrs. Wilkers used to be a grayish brown sort of person, face, hair, clothes, like a sparrow lively and quick. Now she sat, white and crumpled as a small wad of tissue paper in her dusty brown velvet chair watching TV with the sound turned off.

"She always watches TV like that," Donnie said, "she likes to make up her own words and music." Then he said in a loud voice, "Hey Mom, look who's here."

She blinked and fumbled around in the chair looking for

the remote. Her hand shook but she got it pointed towards the TV and turned it off. "Why Johnny, how nice to see you. How is your grandmother?"

"She's fine Mrs. Wilkers, just fine." And I expect she is. Finer than she was in this world. She got real sick when I was in Nam. They let me come home and sit with her and hold her hand and tell her goodbye and that was good.

Donnie snorted and slapped his hand flat on his forehead and mashed back his hair. "Mom, you know perfectly well that Mrs. Lee has been dead for years."

"Oh no dear, you must be thinking of a different Mrs. Lee. Mildred comes to visit quite often. She's my best friend you know."

"Jesus Mom, you can see her house is boarded up. Where do you suppose she lives now?"

"Oh, someplace."

He picked up the photograph in the silver frame and waved it in front of his mom. "Maybe Mildred and Dad live in the same place, do you think?"

"Don't get so upset dear, you know Daddy is quite, quite dead. Squashed like a stray alley cat run over on the pavement. The seam on his pant leg burst open and his leg was splattered all over the ground. Crushed his chest too, yes indeed. Humpty Dumpty, Humpty, Dumpty. In fact, he looked like he wanted to tell me something. He wasn't his usual color of course, not at all."

Donnie wasn't his usual color either. "For God's sake, oh for God's sake." He put down the picture and motioned for me to come outside. He put his collar up against the wind and jammed his hands into his pockets. "See what I mean? And she's going to live with my wife and I. The movers are coming Monday. Let's let her calm down a minute."

What he really meant was he needed to calm down, but I shrugged and we sat in his station wagon out of the wind. Donnie leaned back his head and closed his eyes. "So Johnny, what's been going on in your life these past decades? You were in Vietnam weren't you? Was it bad?"

"It wasn't fun."

"What were you?"

"Nothing."

"Oh well, I went to Canada then and now I'm something. Vice fucking president of a title company. Married, no kids, large mortgage and a crazy mother. Did you ever hear from yours?"

I just shook my head, what was there to say?

"Maybe you're lucky. Mine drives...."

"Listen Donnie, let me talk to your mom a minute. I'll bring her out, you wait here okay?"

Donnie leaned back and nodded with his eyes closed.

When I went back in, Mrs. Wilkers had the TV on again. She hummed and waved her hands at a commercial for Nike. She saw me and said, "Why Johnny, how nice to see you. How is your grandmother?"

"She's fine. I need to talk to you and we don't have much time."

And that scared her to attention. "What is it? What's wrong?"

She grabbed my hand and hers was so small and shriveled you wouldn't think she'd have the strength to squeeze mine till it hurt. "Nothing's the matter. Please Mrs. Wilkers, you're going to leave with Donnie and I might not see you for awhile. You're the only one left."

She sighed and I squatted down beside her chair. I smiled my best smile into her filmy eyes and willed her to answer. "What do you know about Mother?"

"You're very lucky to have a grandmother who takes such good care of you. Mildred is a saint, you know."

"I know." It was no use. I picked up the remote and turned off the TV. "Donnie's waiting, we have to go, but please Mrs. Wilkers, when you see my grandma, tell her don't worry, I'm okay."

Mrs. Wilkers didn't say anything for a second, trying to sort something out in her head. Then her red rimmed eyes filled with tears and she said, "He gave her the dress you know, Gary

did. He gave Ellanor the white dress I wanted. I was very angry. I never had a proper wedding dress and he gave it to Ellanor."

I breathed through my nose softly and I could smell the dress, dry cleaning chemicals and dead carnations. I could feel the lace, stiff and scratchy and Mother's arms enclosed in that heavy white satin holding me down and the ribbon snake coiling around my head and, oh Jesus hold my hand.

"Mildred didn't like that you know, and then what Ellanor did to you was the last straw. She promised she wouldn't anymore and she broke her promise. Mildred didn't really mean to do it, but I was glad when it happened. Ellanor was a bad person and wallowed in death—you wouldn't think she'd be so heavy as petite as she was."

"What, what'd you say?"

"Look how old my fingers are. Goodness sakes, they're all wrinkled."

"No please, what'd you say about Ellanor, about Mother?"

"Hey pal, what's taking so long?" Donnie stood in the doorway muttering and Mrs. Wilkers wiped her eyes with the hem of her dress. "Why Johnny, how nice to see you. How is your grandmother?"

I walked them to the station wagon and gave Mrs. Wilkers a hug. I shook Donnie's hand and he fished a pen from an inside pocket and a business card out of another and wrote something on the back. "Here, my home address, come by and maybe we can hoist a few, talk about old times."

"Sure thing, old times, okay." I'd never see him again.

They got in the car and Donnie waved goodbye and took off fast. But I didn't think it'd be very long before Mrs. Wilkers came back to lie next to Mr. Wilkers. Maybe Donnie'd buy her a white dress.

I stood there for a minute with my hand in my pocket crunching Darla's sequins, then walked across the service lane to Grandma's house.

XV: Jacko

I LEANED INTO THE CHAINLINK AND clung there like a prisoner of war. A hairy old guy in a yellow hard hat strolled over. He had a big wad of chew in his jaw and was hard to understand. "That fence isn't too substantial, it's only temporary. Maybe you oughtn't to lean on it."

"Sorry. I used to live in there, in that house. Can I come in the yard, I won't hurt anything?"

"That a fact? And I bet you'd like to look in the house one last time too."

Now how'd he know that? So I asked him.

"Happens all the time in the demolition trade. Some people want to get in to see if there's anything good left. But there isn't, bud, trust me."

"No really, I did used to live there. My dog Corky is buried under that mesquite tree. A car hit him. My grandma wrapped him in a towel and buried him there. I missed two days of school because I couldn't quit crying."

The old guy took off his hard hat and looked into it, then put it back on. He spit out the wad of tobacco and looked at the house then at me and opened the gate and let me in. "Okay, but I can't let you in the house. If you fell and broke your neck it'd be my ass. You can look in a window though, which one'll it be?"

I pointed to the ground level window in the basement where Mother lived. The old guy took a small breaker bar off his tool belt and jammed it under the plywood covering the window. The nails screeched and groaned and I held my ears. Then the plywood plopped off onto the ground. He picked it up and stood it against the house. "There you go bud, have a look."

What if I looked in the window and Mother looked back? What if she told me to come down beside her?

"Well you gonna look or not?"

Cobwebs and dust covered the glass. I squatted down and saw about a zillion teeny spiders running every which way. I rubbed a spot clean in the middle of the pane, careful not to bother the webs around the edge and looked in.

Of course Mother didn't look back at me. She'd been gone a long time before my sis cleared out the house after Grandma died. They let me come home from Nam when she went in the hospital. I was glad I got to tell her goodbye.

I kept my face pressed to the glass till my eyes got used to the dark inside. The light from the window didn't go very far, but in the dim, opposite corner, I saw Mother's trunk.

"Mother's trunk is there. It's still in there."

"Easy on bud. My men been through every house on this block, save one. Most of 'em have something left. Old clothes, busted furniture."

"Did you look in the trunk?"

"No, but one of my men did I'm sure. We always look in stuff like that. If it was any good, it wouldn't be there. I know what I'm talking about."

He picked up the plywood and pounded it back on. "We're done for today. Your house is coming down day after tomorrow, Monday. Better look at the old neighborhood while you can. Pretty soon isn't gonna be nothing but deaders hereabout."

He rubbed his chin and looked around at what was left. "There's never much to salvage from these old houses. Some white porcelain doorknobs, a few light fixtures. We take it all to the yard. Some of that old stuff winds up in custom homes. You know bud, nothin' ever stays the same."

The loose dirt whipped around in the cold wind and I felt grit on my teeth. The old guy pulled a pouch of tobacco out of his shirt pocket and offered it to me. I shook my head and he turned from the wind and packed in another chew. "We got a few things to clear up. You can hang around till we go if you want—about fifteen, twenty minutes."

I walked around to the back of the house. The ground sparkled with broken glass. A piece of dish stuck out of the ground. I picked it up and rubbed the dirt off. The edge of a plate, blue dots and white and red roses all connected with a thin black line. And I remembered eating fried bologna sandwiches off those plates. Winos have trampled on Corky's grave and crushed pieces of my grandma's dishes and who remembers but me?

The old guy let me out when they left and I thanked him. I had on the same jacket as last year but it didn't seem heavy enough. I'd warm up walking back.

But I was still cold when I got to the truckstop. The sun hung low over the mountains and Sonny Ray was in the parking lot walking back and forth to keep warm. "Thought I had a job Jacko. I've been here half the day. Ralph, you know, the purple Freightliner, wanted me to polish his fuel tanks the next time he came through, which should be by now."

"Kind of late, isn't it?"

"You got that right. My life's two thirds over. I'm not wasting the last third waiting around for Ralph. He's probably stoned in his sleeper somewhere with a bimbo. Let's go eat. I got five pounds of frozen chicken wings from a busted box in the dumpster."

So we went home and built a fire. I got our cooking pot out of the tree. We tie it up there to hide it. Those lowlifes up the wash steal everything because they haven't got anything.

Their places aren't fixed up nice like ours. They live in cardboard boxes. I did that once. It's okay as long as it's dry. If you get wet, you can freeze to death even in your blankets.

I put some water in the pot and threw in the wings. While they were cooking I thought about what Sonny Ray said about

his life being two thirds over. He's only a little bit older than me. So my young part is over and almost the middle. All that's left is being old.

"I went to the cemetery again today."

"Shit Jacko, why do you keep going there, it has to make you feel bad?"

I didn't answer because my mouth was so full of slobbers I couldn't talk. So I just sat and stared at the pot and it did boil, even with me watching it, and finally the chicken was done enough.

After eating four or five wings, I told him about looking in the window and seeing Mother's trunk and about what Mrs. Wilkers said.

He gnawed on a bone, getting off every scrap of gristle and skin. I've never seen anything clean a bone like Sonny Ray, except maybe ants. He fished out another. "Mrs. Wilkers sounds senile. Why don't you call your sister and ask her what she did with everythin'?"

Well, I remember asking my sis that a long time ago, but I can't seem to remember what she said. And since my sis wants me to live with her, she'd want to know why I was asking again, and probably have a fit because she'd think I'd gone crazy in the meanwhile. But, oh man, how else was I going to find out?

"You listenin' Jacko? Call her up and use the excuse they're tearin' down the house Monday and ask if she's sure everythin's out and if she looked in the trunk. I'm going to see if Ralph's in the parkin' lot yet. I gotta lot of crap to figure out."

He didn't wait for an answer, because sometimes I don't. I wiped out the pot and hung it back in the tree.

The light from the truckstop parking lot shines almost all the way back to our place, so it's never really dark like it is in a grave. When I was a kid, me and Donnie used to play in the cemetery. He took a goldfish out of the pond and held it until it died. I tried to get it away but he thought it was funny and wouldn't open his fingers. Why'd he have to kill it?

I pushed him into an open grave and put the planks on and kicked dirt over the top. He hollered for a long time. I buried

the goldfish on top of the soldier's grave—and even after all this time, somebody still brings fresh flowers—then I took a plank and dropped it in the hole and let Donnie climb out. He cried all the way home. I never liked him after that.

When my sis cleared out the house I didn't ask her anything then, I couldn't. I'd sat at my grandma's bed for five days and held her hand. We'd talk about Corky or my Father or Grandpa, but never about Mother.

Towards the end when she could only whisper, I asked her. I had to. "Please Grandma, whatever happened to Mother, please, I need to know?"

"For I've lived all my days under sorrow and my travail is grief. It's all vanity and vexation John Boy, vanity and vexation."

She never said much after that, but smiled and nodded when I told her how much I liked our picnics of fried bologna and mustard sandwiches under the peaked roof on Mount Everest. And then she died. I felt like a car windshield somebody'd thrown a rock through.

I'd never sleep tonight. That's what happens when the bad stuff gets into my head, so I might as well call my sis.

On the way to the pay phones, I met Sonny Ray coming home. He turned around and went back with me. He said, "Beats laying in the dark wondering where my next meal is comin' from."

Salazar answered the phone. I heard him tell my sis it was me and to be quiet a minute for God's sake. I told him what I wanted, nothing surprises him, and his hand went over the phone, then my sis said, "Oh Johnny, are you okay?"

Well why wouldn't I be? Salazar must've said something to her because she wasn't having a fit. She already knew they were tearing down the house. I asked her about my grandma's and Mother's stuff.

"What couldn't be sold, or used, or given away I threw out. I saved all Grandma's books and other bits and pieces you can go through, and I've put away your share of the sale. You weren't here to sort stuff, you had to go back to the army. I loved Grandma too Johnny. I never gave a damn when your mother

left, I was happy to never see her again."

I could hear the tears in her voice and see Salazar standing behind her with his hands on her shoulders and all of a sudden I knew what he meant when he said she was good.

"Don't cry Marie. It's all right. I'm okay."

But I wasn't. Every time a truck went by, the dirt blew down my collar and I had to mash the phone against my head and stick my finger in the other ear to hear what she said.

"I told you all this before Johnny."

And that was right, but I didn't listen then because I didn't have any room left in my head for bad stuff. And now my head was a sweater with a hole in it. My sis had a thread pulling it through the line unravelling my brain. But I knew if I dropped the phone or hung up, Salazar'd have somebody coming to get me before I stepped off the sidewalk.

I thought a big knot in the thread, a couple of knots so I could finish talking. "Why'd you leave Mother's trunk? What was left in it?"

"The bottom had rotted. It was too heavy for me to drag up the steps without it falling apart. The papers and pictures had gotten damp and were all stuck together with black mildew. Two dead mice were in the bottom. Bits of bones and fur. It was trash, garbage. I threw it away, I threw it all away."

She quit talking and took a deep breath. "That was all so long ago."

Salazar took the phone. "You're not okay are you?"

"Really, yes I am, honest."

"Watch yourself Jacko. I'm not your guardian angel, I can't be there all the time."

Sonny Ray scrunched down in his coat and pretended like he hadn't heard a thing. He said, "I hope Ralph isn't broke down somewhere. I was really countin' on that money."

His talking mouth moved but only static came out, squeaking and squawking and I must've fainted or something for a minute or two. When I opened my eyes, his face was a balloon on a string and I said, "Don't tell my sis."

XVI: Jacko

"JESUS CHRIST, OH CHRIST. C'MON GET up before anyone sees. Don't hang your head or lean on anything till we get away from the lights. The cruiser's here bustin' lot lizards and you look drunk. I don't need the hassle."

We went behind the last row of trucks where the desert begins and I sat on the ground with my head between my knees.

"You got too damned excited Jacko. Christ, that's all I need on top of starvin' to death."

And then I puked chicken and it ran under my behind. "I'm not starving to death."

"No you shithead, you can always hit up your sister. I got nobody but some cousins in Kansas. Aw hell Jacko, let's go home."

"I'm not going home, I'm going to see what's in Mother's trunk. Maybe my sis didn't even look in it. She could've looked in another one by mistake. Maybe there's a secret compartment and Mother's in it."

"That's crazy. What if you pass out in the desert?"

Sonny Ray tried to talk me out of it. Said it was cold and dark and I didn't have a flashlight. And that's right. But I had on a coat and a pocket full of matches.

It takes a while to walk a mile or two in the dark. The sliver

of moon gave enough light to see the path through the bushes. The little critters had quit twittering and rustling and the night had a hollow edge, so it must've been late.

I came to the back of the cemetery where the dump used to be and walked on the outside of the old wall to the front. I didn't want to cut through and trip over a sprinkler head.

Just as I got to the corner of the wall, I heard Elvis singing something long gone and lonely and I smelled cigarette smoke. I crouched down and peeked around the corner.

The door hung open on Salazar's pickup. Sonny Ray must've called. I stayed on my hands and knees looking and listening and getting colder and colder.

Why was the door open and Salazar not there? The dome light wasn't on either. The radio played another quiet song and the sharp little rocks poked into my knees. Maybe Salazar fainted. I stood up and went over and looked in. He jumped over the wall from inside the cemetery. He didn't say anything and I knew I was busted.

The wooden kitchen match flared like a torch when he lit a cigarette and the lines in his face looked deep and sad. "I knew the open door would work. Get in."

Nobody ever argues with Salazar except my sis. I did what he said. He took a deep drag then mashed out the butt with the toe of his boot and got in and clicked the door shut.

The heater felt good. My grandma's house squatted in the weeds and trash across the road, and in the dull moonlight looked like a Halloween house. I thought about being in the basement with only matches and was glad Salazar came and picked me up.

He said, "I can get you in there before they tear it down. We can do it tomorrow, Sunday."

Salazar says the past is a done deal, but not for me. I wanted to be alone in my grandma's house. "Well, I've been thinking. I don't know now."

"You worry the hell out of your sister, you know that don't you?"

"I guess so—I'm all right."

"Maybe. Thank about it. You felt colder this winter than last. It takes longer to walk to the cemetery and Sonny Ray looks older than day-old dog shit."

How'd he know all that? I never talk about how bad I feel sometimes, or ask for money very often because then they'd think I couldn't take care of myself.

He let me out in the truckstop parking lot. Sonny Ray had curled up inside the stack of tires out of the wind. When I looked over the top, he asked if Ralph was there.

"No. Let's go home, he'll be here tomorrow."

"I called your sister Jacko. I'm sorry, but you really scared me passing out like that."

He stood up and climbed out and I patted him on the shoulder because I didn't feel like talking anymore, but he did. "It's damn worrisome when you're old and don't have anything. My cousins run the farm in Kansas where I grew up. A poor relative then, and still am, but they'll have me back. I've been considerin' it."

Sonny Ray's said stuff like that before, but I never paid it any attention. After what Salazar said, I looked at him different and he did look older and tireder. You never notice how people fade away when you see them everyday.

I slept late next morning and when I got to the truckstop Sonny Ray was polishing Ralph's fuel tanks. "Hey Jacko, he's stoned in the sleeper with a bimbo just like I said. He paid me ahead of time so I wouldn't bother him when I'm done."

I gave him a wave and headed for the back door of the cafe to see if they had anything a customer sent back, like eggs cooked too hard or soggy biscuits. And, oh man, my sis was there in her dinky red car. She said, "I'm taking you home for breakfast and no arguing or I'll call Salazar."

So she took me home. Salazar lives on five acres in a double-wide mobile home. It took my sis a month to clean it when she first moved in. Me and his little dog Fido used to play hokey-pokey. I'd get down on the rug and he'd be so happy and we'd roll around in the dog hair while I sang a song. He died of old age and Salazar buried him in the back yard, but I made the cross.

Anyways, my sis wouldn't make me a fried bologna and mustard sandwich like I wanted—her pancakes are almost as good though. She asked me about staying and would I please not try and get back to Grandma's house.

I went outside and looked at Fido's grave and thought about having my very own dog. My dog couldn't live like I do, it's too easy to die. But I could have one here.

My sis came down the back steps and leaned against my shoulder and put her head against mine, we're as tall as each other, and I said I'd think about staying.

She got so happy, I said maybe we should get down on the rug and play the hokey-pokey. That was a good joke. We laughed—I finally made my sis laugh. But I didn't say I wouldn't go back to Grandma's house. She was so happy, she never noticed. Good thing Salazar got called in to work because he would've. It'd be too scary to go back at night, even with a flashlight. Right now would be the best time because he was gone.

"Better take me back to the truckstop. I'm supposed to be helping Sonny Ray with Ralph's truck." She held my arm and smiled and I felt bad for telling her a lie. I never felt bad about lying to her before.

She dropped me off in front of the cafe. I wanted to leave right then, but Sonny Ray had to be told about the lie so he could lie if he had to. Lying sure takes a lot of time. Ralph's purple Freightliner sparkled bright in the front row of trucks. Sonny Ray could be anywhere spending his money. I went home and there he was with all his stuff in a little pile.

I thought at first the lowlifes had stolen something again. Then he said, "You can have the cooking pot Jacko, I won't be needin' it. Ralph kicked out the bimbo, I'm going with him east to Texas, then catch another ride up to Kansas."

He picked up his stuff and put it all in his pockets and a bag and I couldn't think of anything to say. His hand was out to shake mine but I couldn't lift my arm, it would mean goodbye. It seemed he held my hand with both of his for a year or two while he said, "You'll be okay Jacko, give your sister a chance."

As he walked away he turned and waved and I finally got

the words out. "Look me up if you're ever passing through."

The only best friend I had, and now he's gone. But I'd think about it later, after I looked in the trunk. Besides, thinking never brings anything back once it's gone.

All the way to the cemetery, I thought about what Mrs. Wilkers said. I know she's not always thinking with all her cylinders, but why would she say how heavy Mother was? Did Mrs. Wilkers kill her, drag her to the oven and cremate her because of the wedding dress? It was so long ago it must be all jumbled up in her head. I never did talk to Salazar about it. Seems like every time I try to do something, I'm a tire with a broken valve stem and everything just leaks away.

I lifted up the loose chainlink fencing and crawled under. The plywood over the window came away easy this time. I tapped on the pane until all the spiders ran away. It didn't matter about the noise so I broke the glass with a board and scraped the edges clean. I held my breath and jumped in.

The cold, heavy air felt thick enough to swim in. I left deep footprints in the powdery dust. I walked to the trunk, thinking how was I going to open it. If the lid fell, it could chop off my hand maybe, or my head if I looked in. Mother might jump out and wrap me up tight with the ribbon snake. I almost ran away. But then Pits started whispering in my head about his grandpa and the Medal of Honor and the brave and wondrous thing he did and it seems like I'm always running away.

I flipped the lid open hard and jumped back. It ripped off the hinges and crashed upside down knocking out a dried up muddauber's nest.

My sis and the old guy were right, just a rotten old box with nothing in it. Something too heavy for her to drag up the steps. I didn't need to go through the rest of the house, it'd be as empty as the basement. My sis did a good job. Poor Marie.

Tomorrow the house would be gone and then I could come and talk to my grandma without having to look at it. I bet she's glad she doesn't have to live in it anymore either. I guess I'll never know what happened to Mother, but maybe I could still have my very own dog.

I went back out the window into the bright day. Sir Edmund died with my grandma and so did John Boy and the son of little King John and now all that's left is me, Jacko. But I'd tell the house goodbye and sit one last time on Mt. Everest.

Mesquites grow slow, but the thorny twigs my grandma kept trimmed had grown back into branches. I could still get up it without getting scratched too bad. When I got to the peak, I pushed in the wooden vent frame with my foot and crawled in.

The sun had warmed it under the peaked roof and made a square of light that I sat in. I looked out at what was left of the old neighborhood and thought about what it would be like when the cemetery people fixed everything up. Corky would be under the mesquite tree forever and I could sit in the shade and visit with him too. And maybe when they tore everything down and it was gone, the bad stuff in my head would go too.

Sonny Ray went back to his family. I don't know if he loved them, but he needed them and maybe it's the same thing. My grandma loved me and I guess my sis loves me, but Mother didn't. Maybe she couldn't. Maybe she had bad stuff in her head too.

I wanted to go home and look at the painting David did for me of the little black-and-white dog.

I turned to climb back out and from the corner of my eye I saw something flutter. Maybe the screen had rusted off the vent on the other end and a bird flew in and was injured.

I scooted into the dimness and saw a pile of rags pushed into the narrow space where the slope ended. It was the old blanket we used to leave up here for our picnics so long ago. A gust of wind blew through the vents and I saw what fluttered. The end of a ribbon, a yellow ribbon, the yellow ribbon snake.

Oh Jesus, please Jesus hold my hand but you can't your fingers are all broken off and I squeezed my eyes shut.

I rolled up into a little ball, a teeny ball about as big as an ant. Snakes don't bother anything as little as an ant. My jaws gritted shut but I was afraid the screaming in my head would puff out my ears so I put my hands over them.

After maybe an hour or a minute, when the ribbon snake

didn't wrap round and round me, I lifted my hands a little bit off my ears and the screams sort of leaked out and away. But I still couldn't open my eyes.

Have you ever walked through a silky, clean thread of cobweb across a path and felt it brush your face? My grandma touched my cheek. "It's okay John Boy. It's okay. You're a man now and can take care of yourself."

My grandma never lied to me, so I opened my eyes. A long piece of yellow snake laid there in the dirt, faded and curled and it was only a ribbon.

I pulled on the corner of the blanket. Bits of rotting cloth fell away from the bundle as it slid across the ceiling boards. I dragged it out of the shadow into the square of light and lifted away our picnic blanket.

Mother. Dried to a crisp and covered with dust. Her papery brown hands were crossed on her hollow chest and she only had two red fingernails left. I wondered what happened to the rest of them? The yellow ribbon was twisted round and round her neck catching her long blond hair and pulling it away from her skull. She wore the white wedding dress but she wasn't pretty anymore. I guess she did go back to her people and my grandma sent her there. My grandma loved me more than anything in the whole wide world.

I picked up the loose piece of ribbon and threw it back at Mother. Her lips, once so soft, were strips of rawhide doggie treats like Fido used to chew on and her teeth stuck out and all that was needed would be a key to wind them up and they'd start chattering. "Phooey on you, phooey on you ribbon snake, you'll never catch me again."

I went back down the tree and under the chainlink and to the cemetery. I lay on my grandma's grave and dug my fingers into the dry grass that scratched my face. "I love you Grandma, I love you more than anything in the whole wide world."

Presently, I stood up and went to the cemetery office and asked to use the phone. Salazar answered and said Marie was at the truckstop looking for me as usual, where else would she be? I told him I wanted my very own dog now that I'd figured

something out that'd been on my mind for a long time and to get here quick because I'd found something really amazing. He wanted to know what, but I said it'd be better if I showed him.

He said, "It better be pretty damned amazing, I'm right in the middle of something."

"Oh it is, hurry." And I went back and sat against the cemetery wall and it seemed I could feel the palo verde trees on the other side growing and pushing the wall against my back and little crumbles of plaster fell off the chicken wire onto the cold ground.

While I waited, I thought about what I was going to name my dog.

XVII: Marie

WHEN I COME HOME FROM TAKING
Johnny back to the truckstop so he could help Sonny Ray with
Ralph's truck, Salazar's pickup is in the driveway. He must
not've had much work or maybe he just needed to sign some-
thing. I park and walk around the back. He's raking where we're
going to set up the pipe corral panels. I blow him a kiss and go
inside.

The smell of Hoppe's No. 9 leads me to the kitchen table. It
is littered with small oily cotton patches. On a pad of newspa-
per his .45 rests, wiped clean of smudges, an absolute sleek tool
of separation. The harsh but pleasant smell of the cleaning sol-
vent brings Rosario to my thoughts. I sit, relax my face, close
my eyes and let him enter the stillness of my mind.

I live in a world of silence. Salazar doesn't talk to me,
Johnny can't, and Rosario won't. Not now. Ah, he did though. It
seemed at times as if I was with a woman. We'd gossip. I miss
that a great deal, well, that and his long devil hair brushing over
my skin and his smooth, quiet touch. He talked so much it
lulled me into thinking I knew everything about his day. Maybe
I'd be with Rosario still, except for two things—he screws
around and he kills people. He never did talk about the other
women. Once the gnawing lust dissipated from my rapturous

heart, or some other organ, I figured it out.

"I'll pick it up. I just took a break from the smell."

"Huh, oh. What smell?" Salazar had stomped into the kitchen and I didn't even notice. My mind and my tongue fumble around trying to become organized and I say the first thing that jumps into my mouth. "Several people have said this. Do you also think Johnny's recent agitation is because Grandma's house is coming down?"

"Probably. Is there any Pepsi?"

"In the back, on the bottom, behind the lettuce."

He digs around in the refrigerator, finds the lone Pepsi, heads for the door and repeats over his shoulder, "Leave all that stuff. I'll clean it up when I'm finished out here."

I want to talk to him about what Johnny said this morning, but I guess it'll have to wait. I gather up all the soiled cleaning patches and put them in a pile. Then I take the pile apart and scatter them over the newspaper again. Maybe Johnny's agitation is rubbing off on me. His going to the cemetery last night is goofy even for him. And this morning, the thing about Fido and coming here and having a dog. I shouldn't have let him leave before I figured out what was really on his mind. Yeah, right.

The mess on the kitchen table bothers me and I want to clean it up. However, that would undermine Salazar's training so I ignore it and stand look out the window. He is still raking. His face is relaxed, his forehead not scrunched up and angry looking as he concentrates on his work. He is too young, I think, for a mid-life crisis, but he too is restless. Perhaps he sees one coming and wishes to avoid it by putting all his leftover energy towards horses. My hands, desiccated artifacts dug out of an Indian burial ground, are too far gone for gloves so I go directly to the shed and take out the other rake.

I work beside him and he stops and squeezes the back of my neck. He holds me together with his invincible arms, a rake handle between us. He says, "You're right, this past week or so Jacko's been different, sly and more on the move."

"Do you think we could get him to a doctor?"

"No, not now. Maybe not ever—unless he collapses."

"What if he's growing a brain tumor?"

"Then he is. Listen my dear, try and put yourself in his place. He lives in his head, in an air castle. His point of focus is your grandmother's house. It's coming down and soon, like the rest of the houses in your old neighborhood, probably the wall across the front of the cemetery too. His world is being rearranged and he's powerless to stop it."

He called me "my dear." I try to hug him harder but the rake handle is in the way. I push my fingers through his hair and pull his face down to mine. I kiss his eyes and lips. "Why do you put up with us, Johnny and me?"

"Neither one of you is boring—and you give good head."

I poke him with the rake handle. He smirks. Once again, he has successfully avoided the issue. Then, because he thinks he got away with using a joke to answer a serious question, I say in a stern kind of voice, "Johnny wasn't as usual this morning. I think he's up to something. I should've tried to sort it out."

"You can't sort him out, but if it makes you feel better, go look for him. That's your thing, isn't it?"

Well. Did I hear the tiniest bit of sarcasm? "I know. You went for him last night and I did this morning and here I go again."

He backs off and tosses the rake between us on the ground. He says, "I wasn't being sarcastic." Golly, he can read my mind now. "It is your thing though and that concerns me more than what Jacko is doing." Then he says something he's never said before. "I don't like you hanging around the truckstop."

"Oh c'mon, I'm not selling my body. A little long in the tooth for that, don't you think? I'd have to give a discount, the merchandise is a little shopworn."

Salazar's eyebrows are a connected black line and, I swear, the vertical line in the middle of his forehead is so deep it could poke a hole in his skull. He says, "I never want to hear you talk like that again. You're always cutting yourself down. I've made a commitment to you I'll never go back on. If a man doesn't honor his word, he's less a man. I love you, I want to marry you, gray roots, your nasty mouth and all. You and Jacko are a package

deal. Without you I'd have nothing but my job." He picks up the rake and stamps the ground with it for emphasis. "I don't want you going to the truckstop because it's no place for a lady."

Sheeit, I'm struck dumb. I've never heard anything so sincere from him before, and yet, the last sentence makes me want to bust out laughing. I swallow it and cough and sniff. I grab him by his belt loops and pull him to me. He stands tall, rake in one hand, me in the other. The words were an aberration, I won't hear their likes again. I pushed him into saying them. Words or deeds? Words not reinforced by deeds are a myth. He's here with me putting up with a lot of crap. Bullshit walks, action talks. Okay, Marcus Fuckus Aurelius, you finally figured that one out.

I hold him to me and say, "Johnny is my absolution."

"Do you want me to go?"

"No, you stay home. The way you're going at it, you must've seen a horse you like."

"I called Carolyn. I'm buying Snort. He'll stay there until I have things set up here. I'll pay her his board meanwhile. He'll be perfect."

I give him a squeeze, pick up the rake and put it back in the shed. There'll be a lot of work setting up the panels and ramada and I'll do my share, but not today.

The mesquite trees are covered with green lace, tiny leaves ready to burst forth and under the trees, stalks of weeds bloom with insignificant yellow flowers. That will have to come first, pulling weeds so we can see the snakes. The car is warm, almost hot, from sitting in the sun all closed up. A lot of dogs die in hot closed cars and kids too. It must be a horrible death. People are idiots. I drive west twelve miles through the low rolling hills to the truckstop. There's only one stop sign and no traffic.

On the side road by the truckstop, all sorts of transient vendors set up business. Some stay longer than others. The turquoise and silver jewelry man has been there the longest. A new guy has strung clothesline from poles to his camp trailer and hung out flags from different states, Mexico, Canada, and the Confederacy. They snap and pop in the wind and if it blows

any harder he'll have to take them down.

The side road is short and little more than an access lane from the back parking lot to the freeway exit. I'm slowed, going north in front of the flag vendor, waiting for a truck to pass headed south to I-10 so I can make a left turn into the lot. Another truck grinds out of the next-to-the-last row and through the space it leaves, I see Rosario's Vette parked beside the same blue Kenworth. Instead of left, I peel right, into the flag vendor's yard.

A gray-haired black man steps out of the trailer bundled in a sheepskin-lined denim jacket and a knitted Navy watch cap pulled down to his eyeballs. "Howdy miss, anything I can help you with?"

I keep my eye on the Vette while fingering a Confederate flag and give the standard reply, "No thanks, I'm just looking."

"Well say now, I ain't a gonna stand with you by them Stars and Bars, heh, heh, our colors clash. Besides, it's too darn windy and cold. I thought I was in Arizona. You need anything, give a knock." And he turns and goes back into his trailer.

Except for Arizona's, I never knew what any of the state flags looked like. Hawaii's resembles a Union Jack and Maryland's a coat of arms. Ohio's, odd shaped, with a double pointed end reminds me of a pennant borne on the lance of a knight. Alabama's is odd, a big red X on a white background. I like Alaska's, the Big Dipper and another star in a dark blue sky.

Then I hear it. Three sharp pops. For a second, I think it's a flag snapping in the wind. The sound speeds through my mind and clicks into place, a 9 mm. Rosario doesn't like the nine, not enough knock-down power, so he didn't do the shooting. Don't be afraid babe, be cool.

A bull-hauler passes. I smell the sour cowshit and want to retch, oh God, my God. The door of the blue Kenworth opens, Rosario holds onto the door and steps down onto the chrome support. He looks at his chest, then into the sun and crumples to the ground. A gringo with curly blond hair, almost ringlets, and carrying a sports bag, jumps out of the driver's door talking into a cell phone. A black Dodge pickup with dark tinted windows

screeches up and the blond man leaps into the passenger side and it roars away towards the westbound exit. It all happens in seconds.

I try to run across the side road, but two big rigs pull out in a hurry, nose to tail, like maybe the drivers saw but don't want to get involved. I dart in front of a moving van. Okay, be afraid babe, just don't panic.

Rosario lies in the dirt, one leg bent and tucked under the other, arms open, head sideways and blood in a tidy puddle beneath him. The image is clear and hard edged, like a painting on the cover of a mystery magazine.

The bad guy didn't miss, three in the ten ring, plenty of knock-down power that close. I crouch and feel the artery in his neck. Nada. I know someone will be here quick. His eyes, hooded by half-closed lids, are turbid marbles that daunt me. His crucifix is stuck in the bloody mess on his chest. I pull the chain around and undo the clasp. The left hand of Christ and that part of the cross is nicked and bent back. Rosario's sleeve, pushed up, reveals his Rolex. It slips off easily. I turn his head without looking at his eyes and remove the diamond stud, a half carat at least. It arcs light into my eye. I stuff it all in my pocket. It would never make it to his estate if I left it on him. Dead drug dealers are fair game. I leave his .45 holstered. Holstered. You trusted the wrong person sweetheart, the downfall of many revolutionaries.

I jump up and do a hurried look through the Vette for drugs or loose money. None. Oh Rosario, how pitiful you look broken and dead. How dare you die and deprive me of my daydreams. I feel like kicking you. Get up man, don't lie there in the dirt where people can see you, so stupid-looking and helpless. Today I mourn, tomorrow, I lie beside another.

My knees tremble and I sink down in the bloody dirt. I lick my thumb and draw a cross on his forehead. Blood on my jeans, blood on my hands, no way I can rise. I crawl out of his life to the clean other side and hold his hand. Say goodbye. And just in case his spirit still hovers, "Tell the man with the beautiful hands, I'd give my life if he could have his back, tell Grandma

I'm sorry for being a shit and, oh yeah, say hello to all Johnny's friends for him, he'd appreciate that."

For man also knows not his time: as the fishes that are taken in an evil net, and as the birds that are caught in the snare; so are the sons of men snared in an evil time, when it falls suddenly upon them. "Oh my dearest, life is a shit sandwich and it was your turn to take a bite." You and me—horse dreams. Sirens in the distance, getting louder.

I wait.

XVIII: Jacko

SALAZAR AND MY SIS HAVE BEEN
really sad ever since Rosario died and I was too for awhile. All
the excitement happened on the same day—Mother showing up
after all these years and Rosario being gunned down. I guess it's
better to have it all over with at once. Poor Salazar.

So I have to look sad and say things like, how awful and he
was so young, even though he wasn't all that young, and what a
shame—except I don't feel it's a shame. If you live by the sword,
you die by the sword. Besides, he's in heaven now with my
grandma and even Mother too. Everybody goes to heaven, even
critters and trees. Heaven is happiness and where there's no tears
and how could you ever be happy without critters and flowers
and friends that did bad things to others but were nice to you?
Once everything arrives in heaven, Jesus makes it good or else.

Salazar said Rosario became lazy and thought dealing drugs
was like any other business, he'd been doing it so long he forgot
it was illegal and that Goldilocks wasn't going to last that long.
My sis explained all that stuff to me too but I really think she
was trying to make sense of it herself. Salazar didn't hardly talk
at all for a few weeks, not about anything, and all my sis did
was creep around with red eyes. I never saw her cry, she
must've done it in the shower.

It's getting better though. We were so busy bringing the corral panels from Rosario's place and setting them up here that there wasn't a lot of time to think. We had the horses boarded temporarily until we put up the ramadas for shade and they're all home now. I can't look at horses standing in the hot sun with their poor heads hanging low, no place to cool off. I'd like to make their owners stand out there with them all day and see how they like it. Horses get skin cancer too. Salazar inherited all of Rosario's horses and half his money. The other half went to the Catholic Church. My sis has his crucifix in a little box on her dresser and on the wall above it is a picture of our Holy Mother Mary.

Every time she passes by her dresser, her face twists into something I don't want to see. Still, even she is happy with the horses. Salazar rides Snort almost every day after work and says he's turning into the perfect horse. He asked me to tell my sis that and I did. She tried a little smile and said, "Yes, he may very well be."

I'm the boss of the horses. Salazar gave me one of Rosario's and is teaching me to ride. I renamed my horse Bucephalus because he's a brave and shiny bay, just like Alexander the Great's. I feed them and make sure their water tanks are clean and filled with fresh water and every day I brush them after I let them run in the round pen for exercise. I clean their feet and keep everything neat and oil the tack and rake the manure and, oh man, it's good.

They built me a tiny little house by the hay shed. It has windows and a door and the painting David did for me hangs over the couch. But the most wonderful, best thing of all is my runty, gray dog Peppy. He's Cocker Spaniel and Poodle, a Cacapoo, but I don't like that word so I call him a mutt. Salazar got him from the pound. I carry him with me everywhere. My sis said if I don't let him walk, his legs were going to shrivel up and fall off.

Peppy likes it when we clean corrals, I let him roll around in the horse poop all he wants. After we worm the horses though, I have to make him stay in the dog yard and he's so sad.

Worm medicine sometimes comes out in the horse poop and dogs have died from eating it but not very often. I don't want to take a chance, I clean up every scrap and wait three or four days before I let him and the other dogs out.

We have four dogs now. My sis found one at the truckstop when she was moving me to here and two wandered into the yard a month or two ago. People dump them in the country. The little dogs die in a few days or get eaten by coyotes and the bigger ones form dog packs that kill cows and goats and then the ranchers go on dog hunts. I named all the dogs—Barney and Christi and George—but they don't know their names yet. They all come to me when I say, "Here doggies." They're good friends for Peppy.

I made Salazar and my sis promise that they'd never get rid of any of the critters, even when they got old. My sis said they'd keep them, "Till death do us part," and then her face sort of melted and she turned away.

They asked me did I want a TV. What for? I don't have the time for that, being the boss of the critters. I do have a tape though that I'm watching on their TV. It's me. I talked to the whole United States about finding Mother. Imagine that, all those millions of people listening to me, Jacko, who used to be John Boy. Rosario only appeared on the local news once. My sis told me he'd been shot three times and the news said he was gunned down in a hail storm of bullets and that he was a suspected drug dealer. Some suspected, some knew, nobody ever proved it.

The lady who interviewed me was so nice, she called me Mr. Lee. It seems strange to have a last name. I've watched the tape a lot because I think I look pretty good in my red Arizona Wildcats sweatshirt. Salazar is standing behind my chair and my sis is sitting beside me and the only thing I don't like is, she's holding my hand like I'm some kind of little kid, but I didn't notice it at the time.

I turned off the TV and rewound the tape. Salazar and my sis are going grocery shopping and they're dropping me off at the truckstop so I can buy a card for Sonny Ray and hang out.

They'll pick me up when they're done and then we're spending some time at the cemetery.

Peppy and me stepped on over to our place. Back and forth, between here and there, he likes to run around and pee on stuff. Dog pee is magic. It keeps the demons away. I picked him up and carried him in and put him on the couch. "Okay Peppy, I'll be away for a little while but I'll be back, don't worry." He won't look at me when I'm leaving. If I forget to pick up the trash container, when I come home stuff is all over the floor, and, if I remember to put the container on the counter, he pees on the shower curtain. That's okay, it's the only way he has for telling me he's upset that I've left him alone.

I already cleaned his cookie dish and water bowl and filled both. I do that first thing in the morning, then he has his real supper with my sis and Salazar and me in the evening.

They stopped in front of my place and tooted the horn. It's hot now, and dry and dusty but Salazar's new Ford pickup has good air conditioning. He still hasn't sold Rosario's Corvette, it's in a locked metal garage behind my house and the hay shed. He starts it up from time to time and drives it a mile or two down the road then turns around and comes back.

On the way, total silence. They usually argue over what station they want to listen to. Salazar likes country-western and my sis wants the classic rock one. She almost always wins. The Stones, the Eagles and the Beatles are okay, but Fogerty singing "Bad Moon Rising" is scary—like Revelations. And some, like AC/DC and Queen, I can't understand. That's why I like Elvis, he only sings to me.

When they dropped me off at the truckstop in front of the gift shop my sis didn't say anything except, "We'll meet you here at two o'clock. Have fun."

"Can you make it earlier, we have to go to the cemetery and I don't want to leave Peppy too long and the horses will be expecting their treats."

My sis looked at Salazar and he nodded. The lines in her face folded into a smile and she reminded me of my young Grandma in that old black-and-white photograph of her stand-

ing in front of the school where she taught English before the world began.

I went into the gift shop. In the old days, I'd only looked in the window. There wasn't any reason to go inside because they didn't have food. I'd never seen the lady behind the counter before. Her name tag sagged from the thin material of her tee shirt "Can I help you sir?"

Sir. I rolled that around in my head. She called me sir. She must've seen me on TV. Nobody ever called me sir at the truck-stop before. "Please Sarah, I'd like a nice card with a sunset for my friend Sonny Ray back in Kansas."

She came from behind the counter and led me to the card rack. It turned round and she looked at the top ones, then, because her fat in the middle got in the way, put her hands on her knees and sort of squatted over and looked at the bottom ones. I moved beside her so I couldn't see up her skirt when she bent over. We were doing business and that wouldn't be polite. She said, "No sunsets on this side, give it a spin."

So I did. But you know, there weren't any sunsets. She pulled out a dozen or so others, one at a time, and we talked about each picture. Finally, behind a birthday card, she found one of two cowboys sitting on horses looking down a beautiful canyon. "That's it, that's the one," I said. "Why that could even be me and Sonny Ray."

Sarah found an envelope that fit and carried it back to the register. "You certainly have good taste. I'm sure your friend will really enjoy it."

She took my money and gave me change and I said thank you and she told me to come back again sir and I think I will because they must not do much business and she's very nice.

Then I went to the service place and bought a stamp and borrowed a pen and wrote to Sonny Ray about me learning to ride and Peppy and the dogs and I hoped he was having fun being boss of the chickens. I gave back the pen and mailed the card.

Now what was I going to do? I should've stayed home with Peppy but then I couldn't have bought the card and I sure didn't

want to go with my sis and Salazar to the grocery store. I don't like old ladies running into me with their grocery carts.

I sat down on the curb in the shade of a billboard and thought. It's not the same at the truckstop. Everybody knows I have a new life and they don't give me free doughnuts anymore. Besides, most of my friends are gone up or down the freeway. I shaded my eyes with my hand and looked around—maybe I'd see someone I knew.

Two guys with packs came walking down the exit, but I didn't know them. As they passed by I said, "Hi, how're you doing?" One guy nodded, "Not too bad," and they kept on their way towards the parked trucks. Their stuff was grimy, but good. They weren't lowlifes. Lowlifes don't carry anything.

The eighteen wheelers rumbled by and the gritty buildings were still the same, familiar, but distant in my eye, like something I'd forgotten and had to remember all over again. The past shimmered in the mirrors of my mind and I saw me and Sonny Ray in our place by the wash and how we lived and I'm happy he's in Kansas.

By and by, Salazar and my sis pulled up and she opened the door. I looked at the big ice chest and the tied bags of groceries in the back of the pickup and she said, "Yes, I didn't forget Peppy's bacon-and-cheese dogfood or the bologna and mustard. Get in and put on your seat belt." I still haven't figured out how she always knows what I'm thinking and away we went to the cemetery.

Maybe it was because my sis didn't feel like arguing today that she brought a Beatles CD. "Yesterday" played softly and I hummed along. It didn't take long and we were there.

My grandma's house and all the rest were gone, even old Mrs. Wilkers; though there's still a chainlink fence around it all. Most of the landscaping is done but there's no dead people living there yet. The mesquite tree that Corky is buried under has a concrete bench over his grave and when the fence comes down, I can sit and visit. Maybe I can bring Peppy and they can be friends.

Mother was on TV too, covered up and strapped to a board

to keep her from falling apart. All the cops and firemen stood looking up at the peaked roof as she came down Mount Everest just as if she was a movie star and not only a bundle of twigs. They put her in a white hearse with covered back windows. My sis wouldn't give the news people a picture of her and after my interview, wouldn't talk to them any more or let me either.

For awhile after, a cop car with two cops stayed parked at my grandma's house until the cemetery people pulled it down. All that time and Mother in there. That's why I couldn't get away, she wouldn't let me go. When they got done with peeling Mother apart, I wonder if they pieced her back together or put her loose in a bag, like stale, hard tortilla chips, before they cremated her?

My sis told them, be sure and burn the wedding dress and I told them, be sure and burn the yellow ribbon snake too and now it can never get me again, ever. They asked did we want the ashes and my sis said you can throw those F-wording ashes in the wind.

Salazar pulled into the cemetery and parked in the lane by Jesus the Good Shepherd. Rosario is buried in the square opposite. The green clipped grass doesn't look real, but it is and you can still see the outline of the grave in the sod. I stood quiet and thought a minute about how much more alive Rosario was than most men. Doesn't seem to matter how alive you are, when you're dead, you're as dead as the lowest lowlife. My sis had bought a bouquet of white carnations at the grocery store. She took the cellophane off and handed it to me. I crumpled it up and put it in my pocket.

My sis's eyes leaked tears like the faucet I let drip into the bird dish and Salazar's face was as hard as a tombstone. I never know what to say to either one when we come to the cemetery, they don't seem like they belong here. So I did like always and went and sat at the feet of Jesus.

I leaned against His robe and closed my eyes and listened and pretty soon the pale murmurings seeped up out of the ground. The whispers were as soft and warm as a horse's breath and somewhere in the faint twitterings, I heard Rosario's lisping

accent. He was far away still and I couldn't quite hear what he or the others said. That's okay, they'll be there forever.

My sis gulped back a sob and I looked at them holding hands, hovered over the grave, my sis shrunk into herself, quiet and afraid, Salazar standing there like a statue waiting for a bird to poop on him. They acted like they were never going to see Rosario again.

I stood up and walked over to the pickup and said real loud, "Peppy's waiting for me. I want to go home."